Healing Ground

A Visionary Union of Earth and Spirit

Photography by TRISH TULEY / Poetry by MYRA DUTTON

CELESTIAL ARTS

Berkeley, California

Celestial Arts
P.O. Box 7123
Berkeley, California 94707
www.tenspeed.com

Distributed in Australia by Simon & Schuster Australia, in Canada by Ten Speed Press
Canada, in New Zealand by Southern Publishers Group, in South Africa by Real
Books, and in the United Kingdom and Europe by Airlift Book Company.

Cover and book design by Betsy Stromberg

Library of Congress Cataloging-in-Publication Data

Tuley, Trish.
 Healing ground : a visionary union of earth and spirit / photography
by Trish Tuley ; poetry by Myra Dutton.
 p. cm.
Includes index.
 ISBN 1-58761-201-1
 1. Landscape photography. 2. Nature (Aesthetics)—Pictorial works. 3. Nature in
literature. 4. Spiritualism in art. 5. Spiritualism in literature. I. Dutton, Myra. II.
Title.
 TR660.5.T85 2003
 508—dc21
 2003001940
Printed in China
First printing, 2003

1 2 3 4 5 6 7 8 9 10 — 07 06 05 04 03

For Roger, Tara, Marissa, and Sterling,

and for Delene and Edmund.

May you always find healing ground.

HEALING GROUND

Acknowledgments

Special thanks to Dave Chapnick, Sam and Char Arno, and Bill Underwood for their friendship and support all these years; to Michele Marsh and her "kachunker" machine; and to Leigh Humphrey, Debbie Crowell, and Eric Metzler. In grateful memory of Papa Tuley, Rosemary Jakeman, and Tom Thompson, who guide me still. Lastly, to my best friend and canine companion, Luna, who waits patiently while I see and catch the image.

—*Trish Tuley*

Many wonderful people inspired and supported this book. I am deeply grateful for the love and wise counsel of my family, teachers, and friends. I especially want to thank Marshall, who has guided me for several years; and to recognize Phil Jones and Bill Mawhinney for their insights during the initial stages of this project. Thanks also to Careena Chase, Chris Fox, and Victoria Chamberlain for our innumerable long walks and conversations.

—*Myra Dutton*

We both wish to thank Jo Ann Deck, our publisher, and Philip Wood, owner of Celestial Arts, for their faith in *Healing Ground*. Many thanks to Brie Mazurek, our editor, for her enthusiasm and hard work; to Laurie Fox and Jeff Salz for their kind advice and encouragement; and to Ajahn Chaiyot for his blessings and gentle wisdom.

Introduction

THE PHOTOGRAPHER'S PERSPECTIVE

Having grown up in rural Tennessee, down in the foothills of the Great Smoky Mountains, I have always felt that my relationship with Nature was paramount. As a child, I felt truly at home in Nature, whether on a long solo bike ride with only my mayonnaise jar filled with ice water, or on foot exploring the woods beyond the field across the road. For me, these intimate moments with Nature were both a thrill and a comfort.

After college, I moved from state to state, ultimately landing in Los Angeles, where I became involved with the corporate world of finance. But after almost twenty years, I was no longer challenged in that setting; I was disillusioned with its motivation for profit, which was often at the expense of the environment. I needed to get perspective, and so I left Los Angeles and moved to the remote Washington seacoast. Walking along the peninsula, I began to see a beauty I once felt in Tennessee. With a borrowed camera, I started my journey to recover that childhood intimacy with the natural world, jotting down my thoughts along the way, and matching them with my images. Far from family and friends, I began to reconnect with Nature—my true mother and home.

I spent much of my time on the Olympic Coast and in the Hoh Rainforest, where I was mesmerized by the sense of being in a long-ago time when natural order prevailed. The untouched world revealed itself to me in so many ways: meeting deer on the trails; stumbling upon nurse logs (gigantic fallen logs with young saplings growing out of their old bark); encountering huge trees and other magical drift wood washed ashore on Ruby Beach during storms.

I have always liked photography and had been encouraged by friends to pursue it. After a few months of learning the technical aspects, I began to feel that I could use this skill to communicate the intimacy I felt with Nature, to help others see the beauty and to inspire them to honor and respect our planet. I continued my project, and *Healing Ground* eventually emerged as my reason for being. Years passed and after showing my book to others, I realized that what I'd written to accompany the photographs

was just an expression of my personal healing. I asked Myra if she would collaborate on a book with my photographs and her poems.

All my photographs are taken as they are given, in natural lighting, without colored filters or digital enhancement. I use the "wow" factor in determining a potential photograph. When a scene speaks to me, I stay there a while or return to see the magic—I know it's there.

I want others to realize that the Earth can heal us. When we rekindle our deep respect for the Earth, we will stop destroying it. I am passionate about preserving Nature and when I can contribute to that endeavor, my spirit soars. Nature is my meditation, my classroom, my inspiration. When I am troubled, I retreat to my sacred spot. I talk with Nature; in stillness, I listen. The answers always follow.

THE POET'S PERSPECTIVE

As a child born and raised in rural Iowa, I ran within clouds of countless iridescent dragonflies, all sizes and colors. The grove outside my bedroom window had two gnarled "butterfly trees," which were covered with migrating Monarchs every year. I would lie in tall prairie grass, daydreaming and writing poetry. My mother encouraged us (my three brothers and myself) to collect leaves, insects, and minerals; to note geological and cloud formations; to study the artifacts and ways of the Dakota Sioux who once lived in these rolling hills; and to search for fossils along riverbanks. We were always looking for signs and symbols around us.

My world changed as I moved from one city to another. Throughout my travels—from the Australian Alps to Spain's Mediterranean Coast—Nature revealed its secrets to me. Its wisdom, lying two or three layers beneath the surface, affected me profoundly. When I finally found the deciduous and evergreen forests of Idyllwild, California, I knew I had come home.

This wilderness became my sanctuary and inspiration.

I hiked almost every day for eleven years, knowing that Nature would heal my sensitive soul. My writing changed. As I walked, lines of poetry were born into the rhythm of my steps. I wrote it all down, praying to my beloved mountains, to wild ones with their ears to the wind, to petals laid in full surrender. My spirit was mirrored in the beauty of creation.

I had seen Trish's slide presentations at the Idyllwild Earth Fair and could feel her intent, the energy within her. Trish's deep reverence and love for Nature seemed akin to mine. Certain photographs, such as *Helping Hand,* moved me to tears. When Trish asked if I would collaborate with her on a book, I immediately agreed, for I recognized the essence of her photographic work; her shining images would illuminate my world of metaphors.

A large portion of *Healing Ground* was created independently. Correlating our work was an amazing process. As we spoke of our experiences in Nature, poems and photographs fell into place. Sometimes Trish would travel hundreds of miles for the perfect visual for a poem, or I would be haunted by an image that demanded a poetic complement. Then there were the incredible days when we met with our new work and discovered that it was already interwoven and beautifully matched. Our book had developed its own life and soul.

Trish and I have walked thousands of miles in the wilderness as environmental advocates, voluntary fire lookouts, and Nature enthusiasts. This book is the evolution of our perceptions as guardians and friends of Mother Earth. We hope that *Healing Ground* brings a calm to our ravaged planet, and that it inspires mankind to once again honor the beauty of Nature and be healed.

Wishing you peace,
Myra Dutton and *Trish Tuley*

True Mother

In ancient groves of shimmering light,
I rest my brow on furrowed bark,
listening to the slow cadence
of the Mother's forested heart,
and hear my name rise from the depths,
long and drawn out, with the query,
Do you know how much we love you?

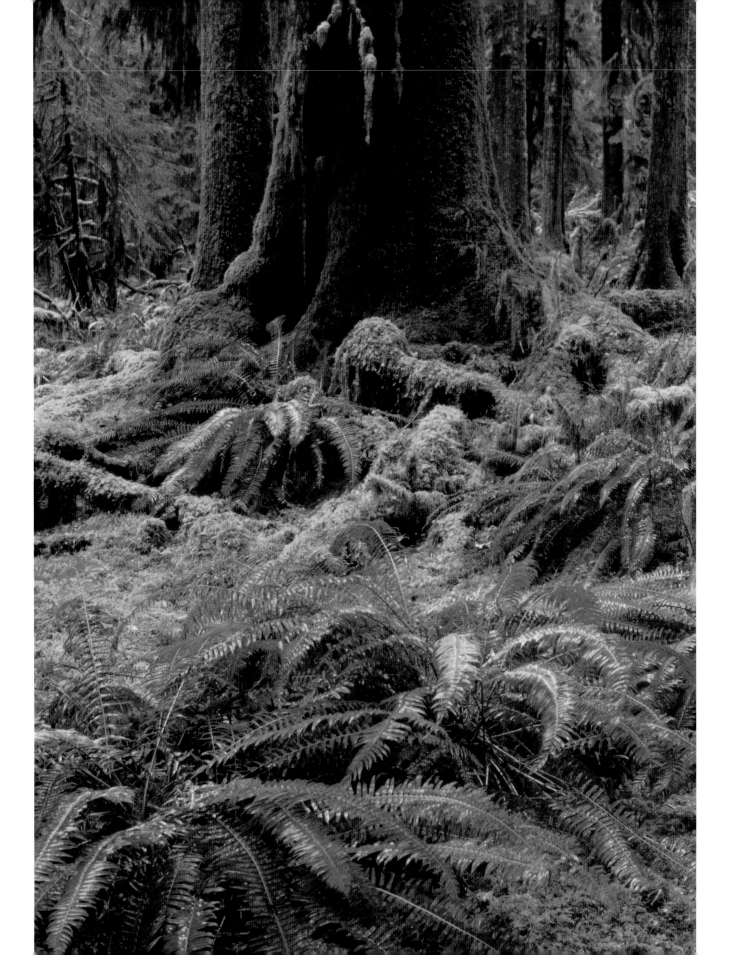

My true heritage is found in the wilderness
with the tallest trees as my teachers,
where love does not go unheeded
but is felt on the mountaintops,
in green glens and meadows,
and in the ever-changing
magnificence of the skies.

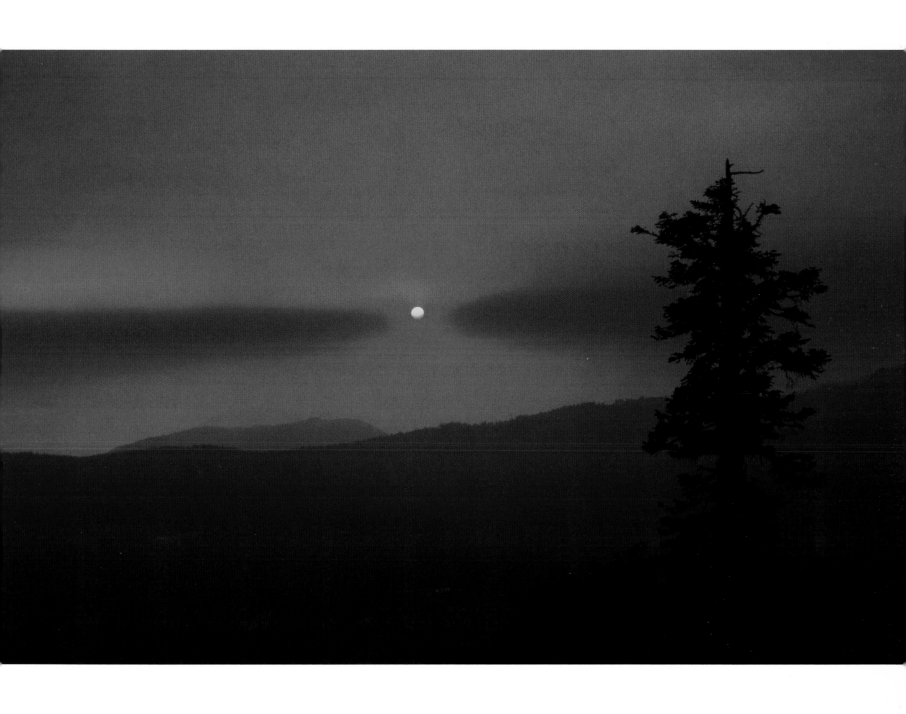

Illusion

In a world where image is everything,
mankind has lost its vision.
We close our eyes to the sea,
the soul, the stream of tears,
and wonder if the tide will ever change.
It is no small task to be human,
learning the ebb and flow of life
by Braille.

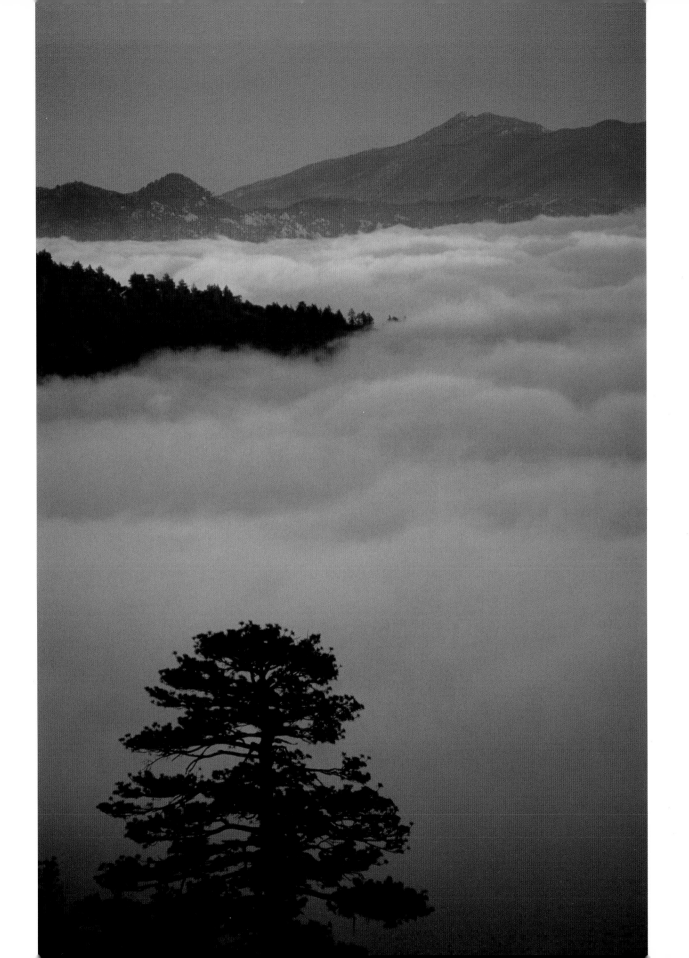

Standing Stones

Speak your truth
like a standing stone on the mountain,
born from the overview and serenity of focus.
Honorable intent echoes across the countryside
in shining testament to the good in all beings.
O Guardian of the Wilderness,
teach us to love what we once feared.
Invoke the stone circles,
the living granite sentinels,
to herald the end of human despair.

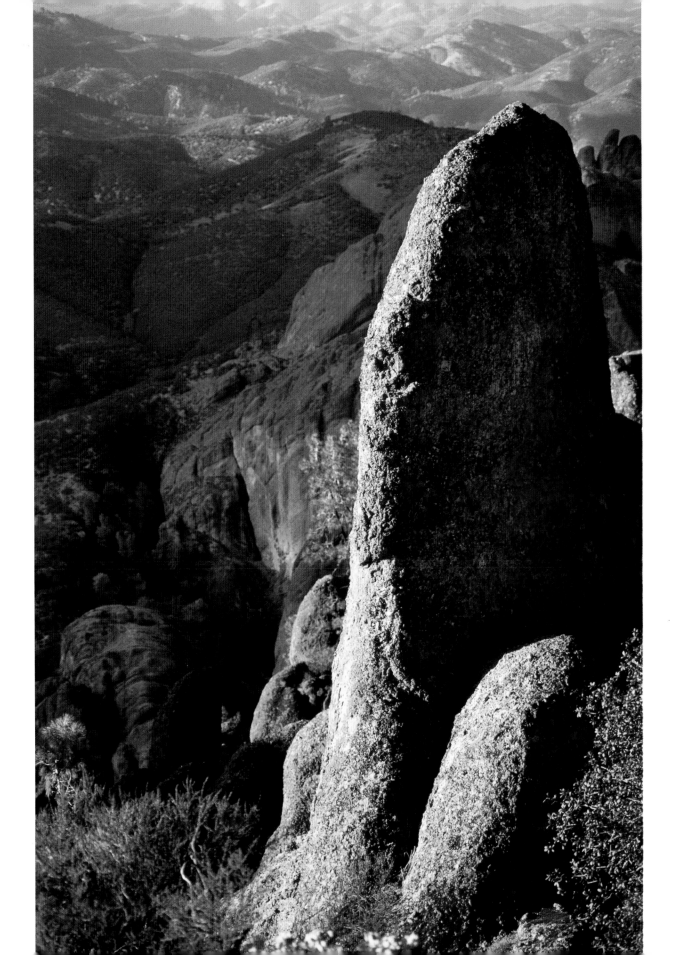

Lady of the Wood

Ruby-crowned kinglets lie low,

waiting for the Lady to appear,

while fingers of mist reach for the mountaintop.

Spirits of cedar and spruce emanate peace,

the sylvan heart pulsing in the stillness,

the unspoken message clear:

Love is possible on Earth.

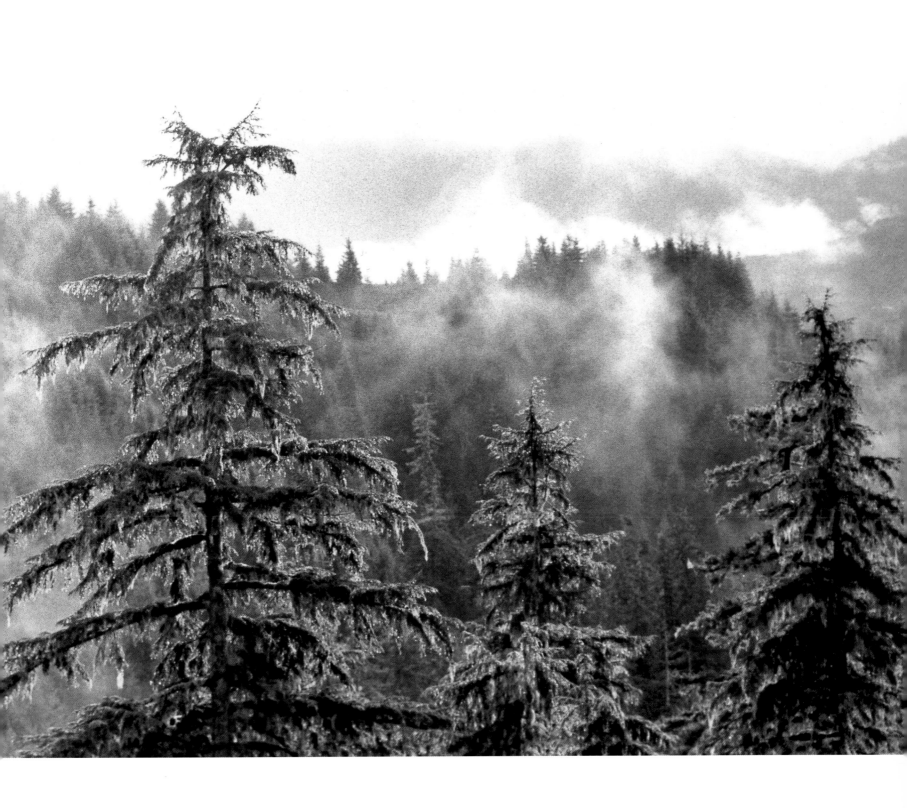

Riding the Sacred

I have heard the secrets here,
felt the breath and beat of wind
across the grass-maned prairie,
and I climb on the back of this Earth
as if I had journeyed centuries before,
her wild hair twined in my hand.

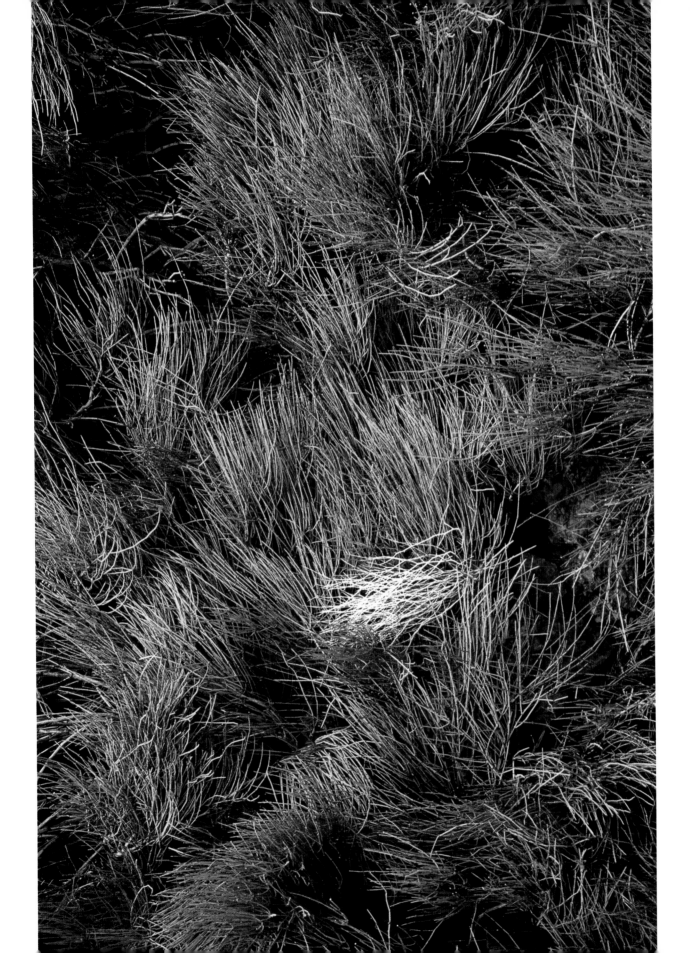

Until We Meet Again

Gliding silently across another time,
guided by a wisdom vast as the skies,
I gaze upon the steplands of life,
the setting sun aglow in my eyes.
All I see is beauty.
All I feel is love.
All I hear is the call
of a people, long-forgotten,
who followed the trail of the wind.

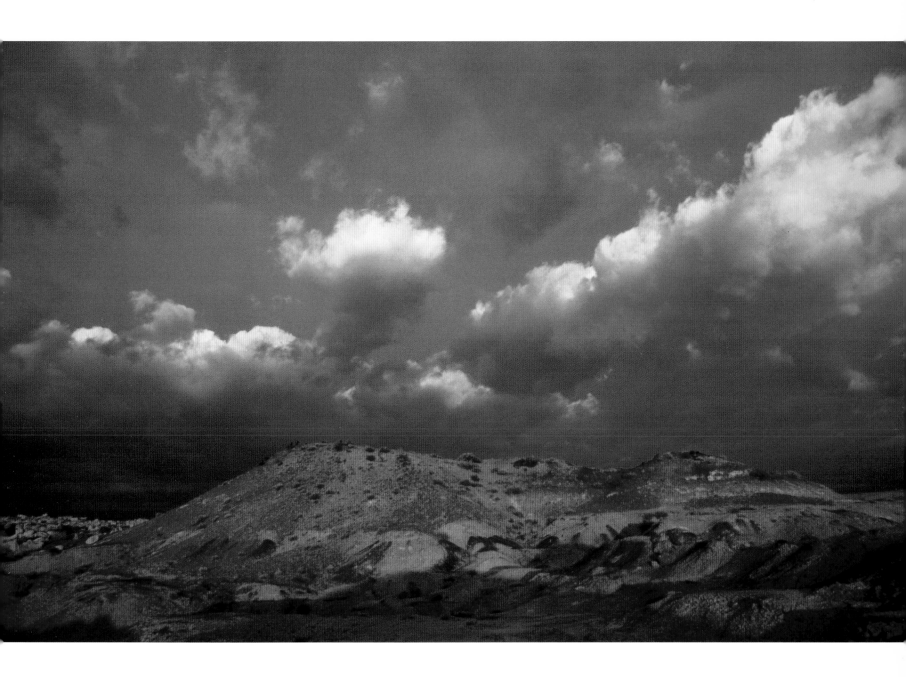

Rainbow People

From the rare hoop of the sacred,
rainbow people are returning to Earth
through cracks in the world,
announcing a new epoch's birth.
It is time to shed our skins,
to reveal the light we once were.
Fire opal beings remind us that
even in the midst of winter lives spring,
and in the midst of chaos lives divine order.

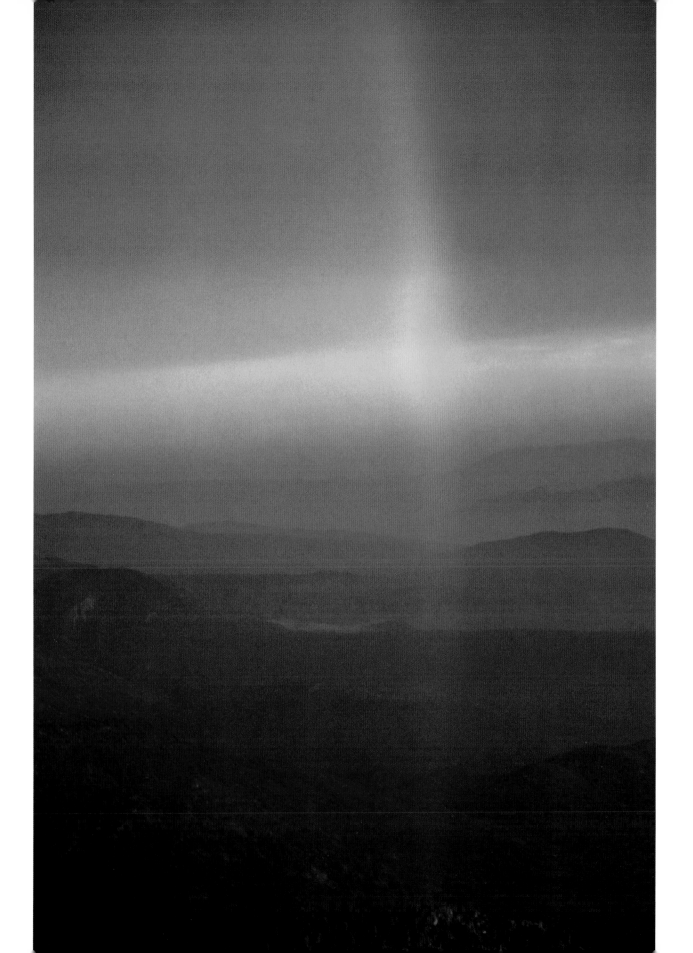

Dreamtime

An altar lies on the mountaintop,
watching, pulsing, waiting.
Blue mists arise and vanish,
bringing to light its presence.
Dimensions slip. Hawks cry.
Who hears? Who sees?
Who feels the magic of other realms?

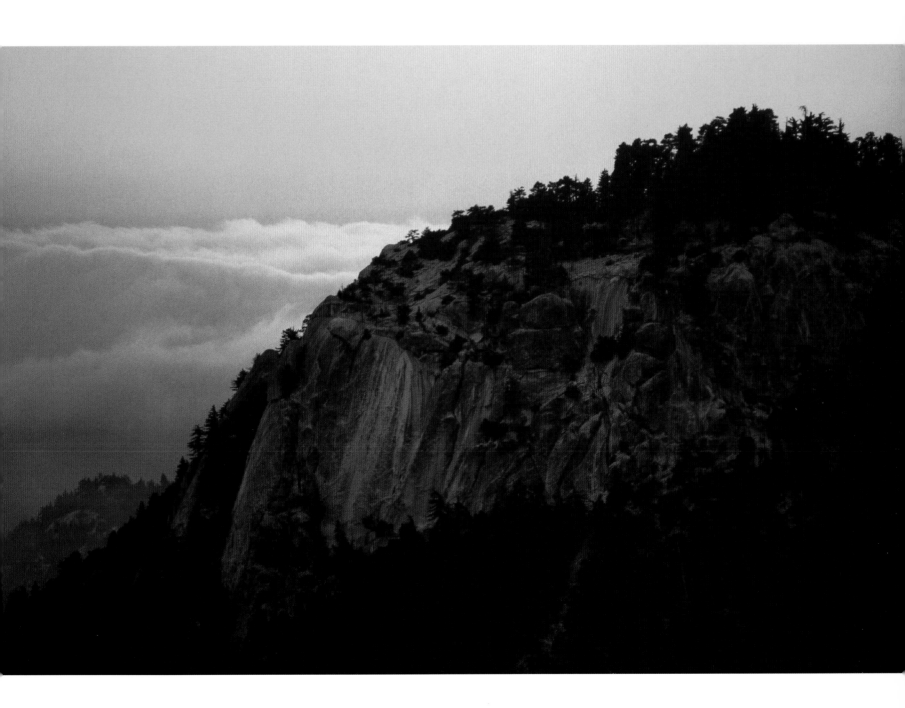

Helping Hand

The Mother is,
always has been,
and always will be.
We are her children,
unlimited beings,
one with the Mother of Creation.
Proclaim her name,
and in the echoing silence,
feel her timeless touch.

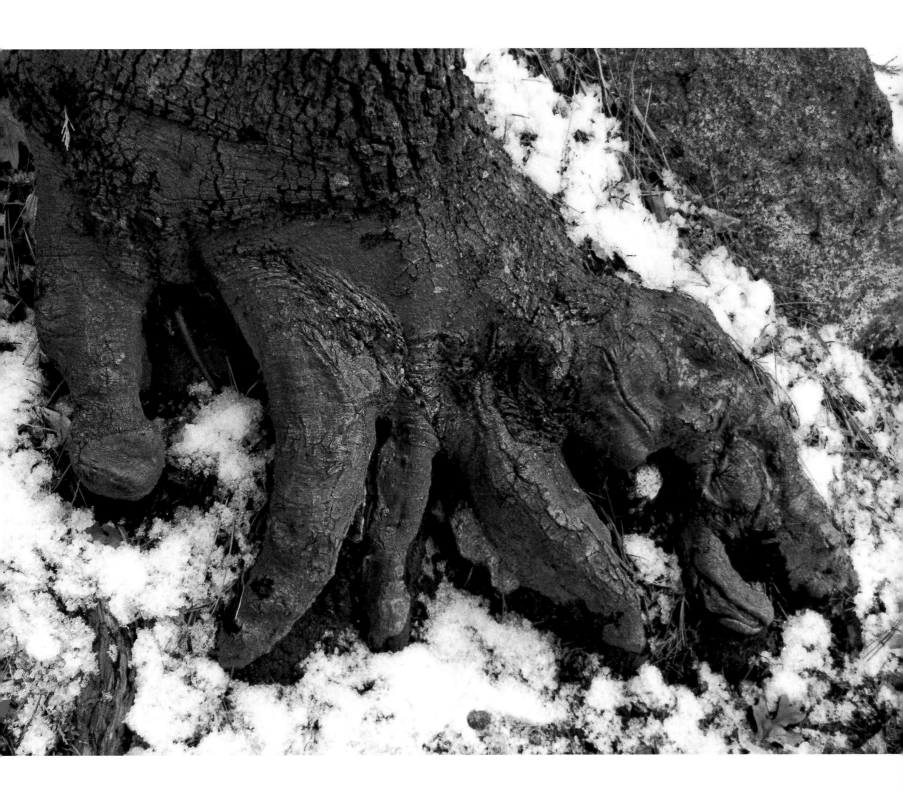

Owl Heart

Invincible through the blackest night,
the clear-eyed moon emerges,
complete, encircled with light.
O Protectress of the world,
your sacred fire is my own.
Your curving surge, your fathomless depths,
your changing tides—my home.

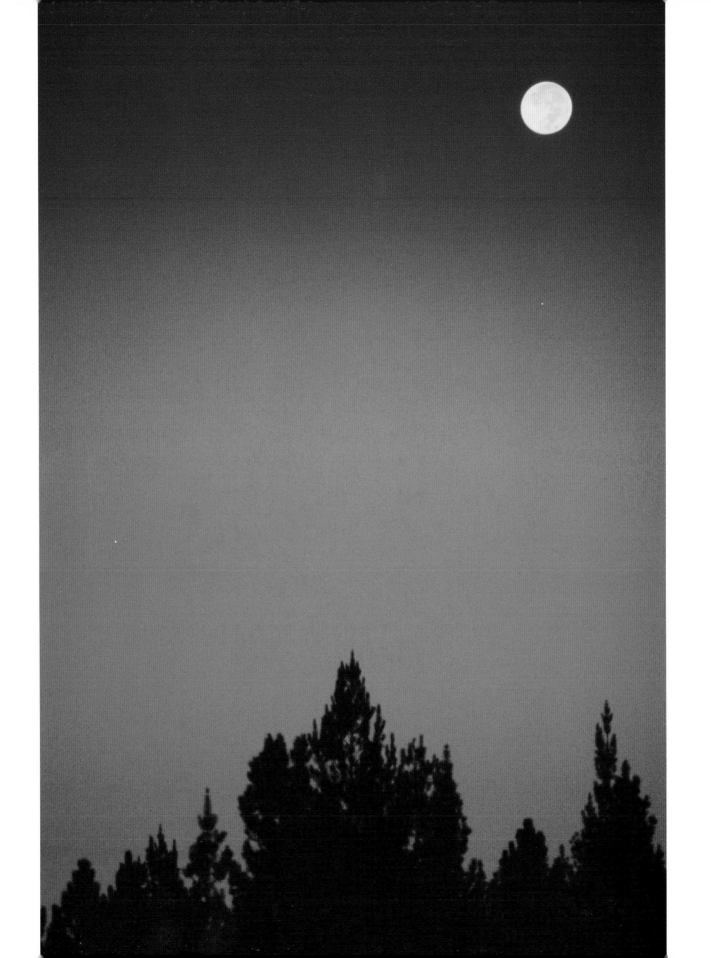

Healing Ground

From the mountain's arched back,
I trail the flight of a red-tailed hawk
over a gleaming pearl
and listen to the mother tongue.
After countless winters of incubation,
my eyes open to a beautiful morning
and my star-lined mind,
harmonious with the Earth,
springs from the healing ground of angels.

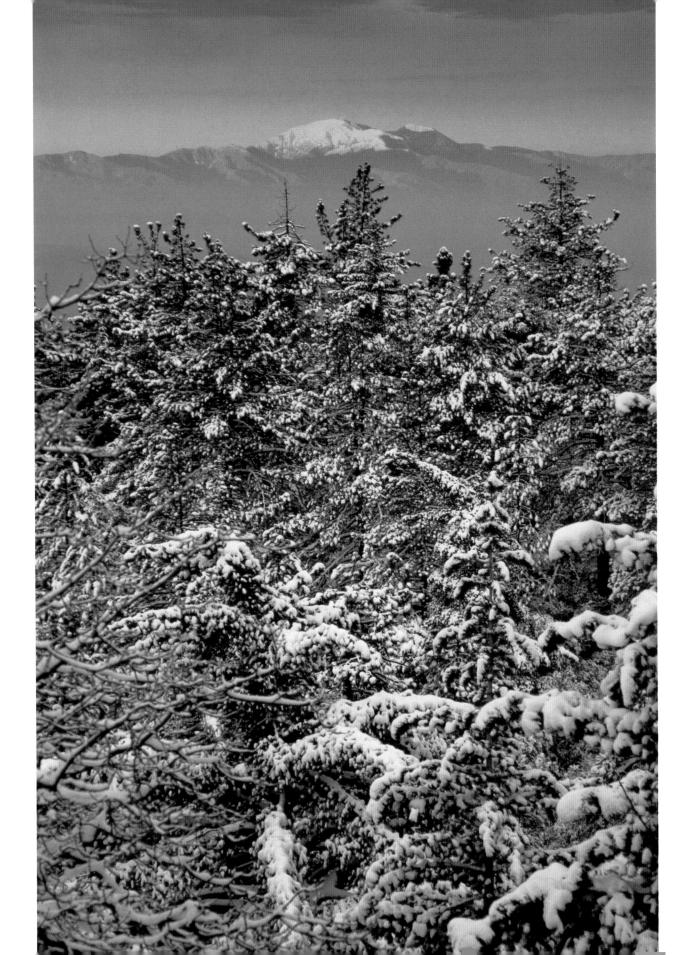

Conception

As a child I built snow caves
and lay inside winter's might,
discovering within me
ideas and dimensions
concealed under ten feet of snow.
Images appeared across the white screen.
Inner thresholds melted upon touch
and haloed the moon.

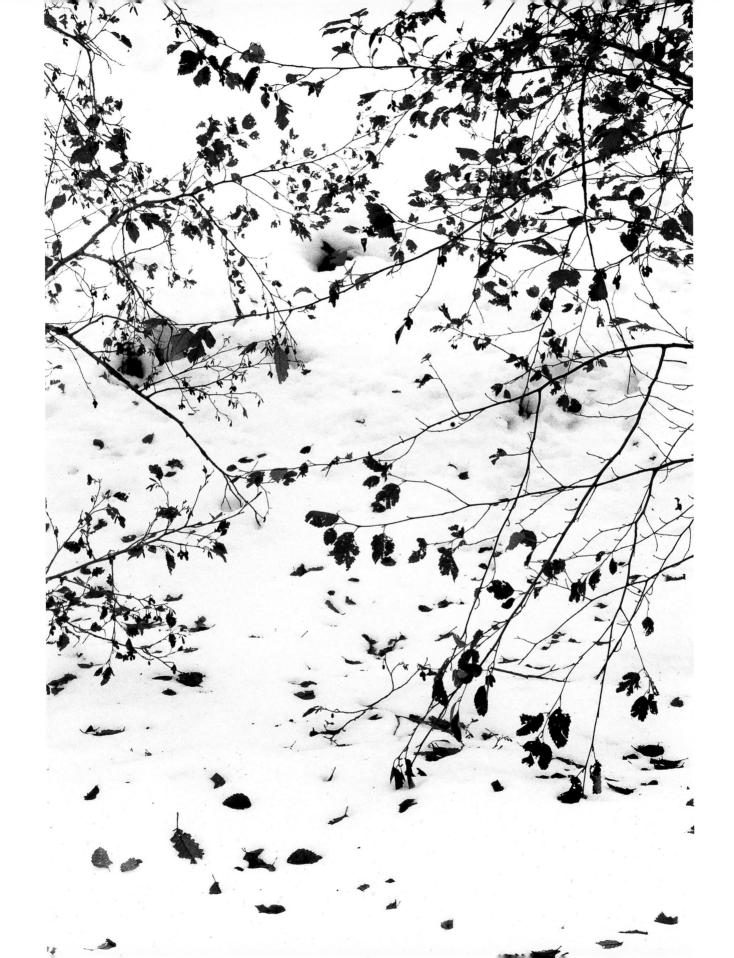

Moon Cradle

I feel your warmth within me.
A still summer twilight
cradles the moon,
lending vivid intention to
the night before dreams.
As I move into the heart of you,
gentle rain falls around me,
silently germinating love.

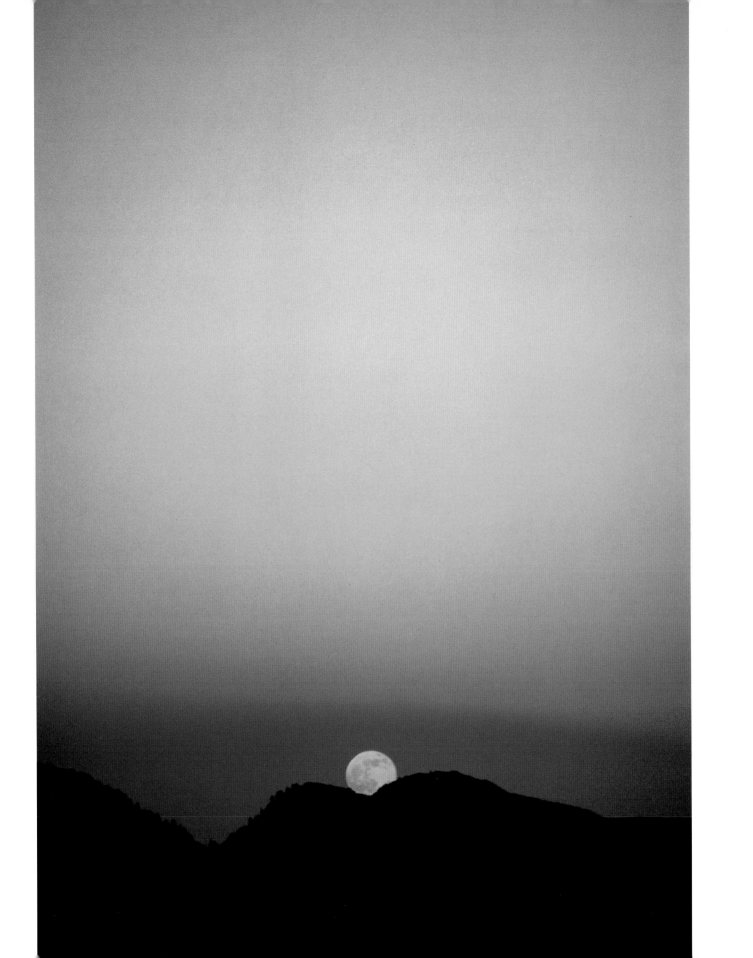

In Spiritu Sanctum

Tangible as soft velvet, the Mother's breath
ripples the rainforest canopy.
Swaddled in moss and lacy fern,
broad-leaved maples nurse from her dripping breast,
lulled by the never-ending songs of her heart.
All this we know to be true.
When we give love to the Mother,
love is always given in return.
Love will sustain the Earth.

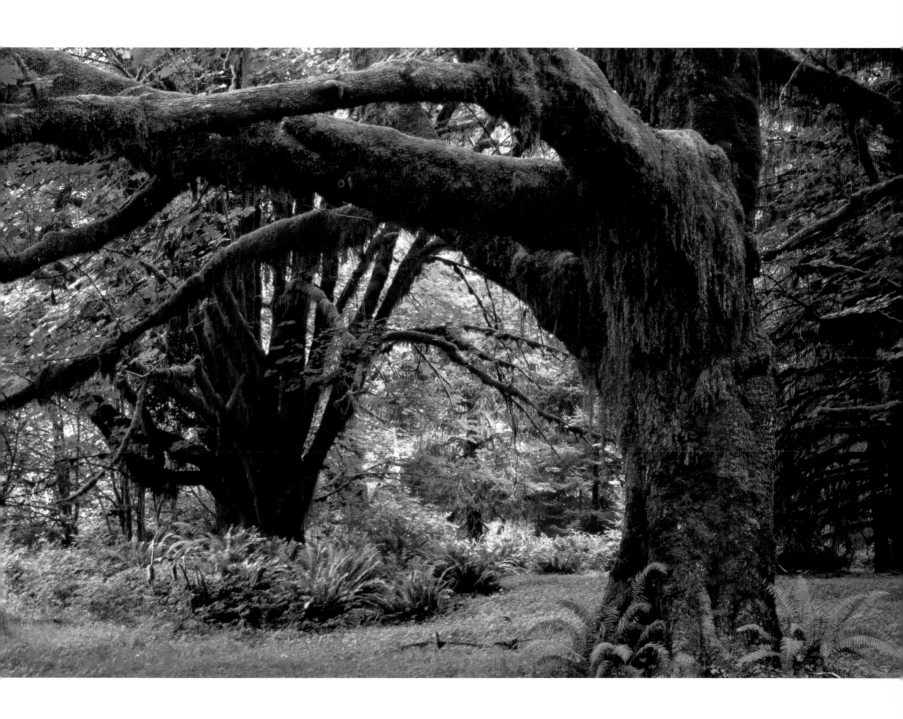

Joy

Love is infinite, immortal,
cellular and universal,
an ocean sanctuary
pulsing with the purity of life.

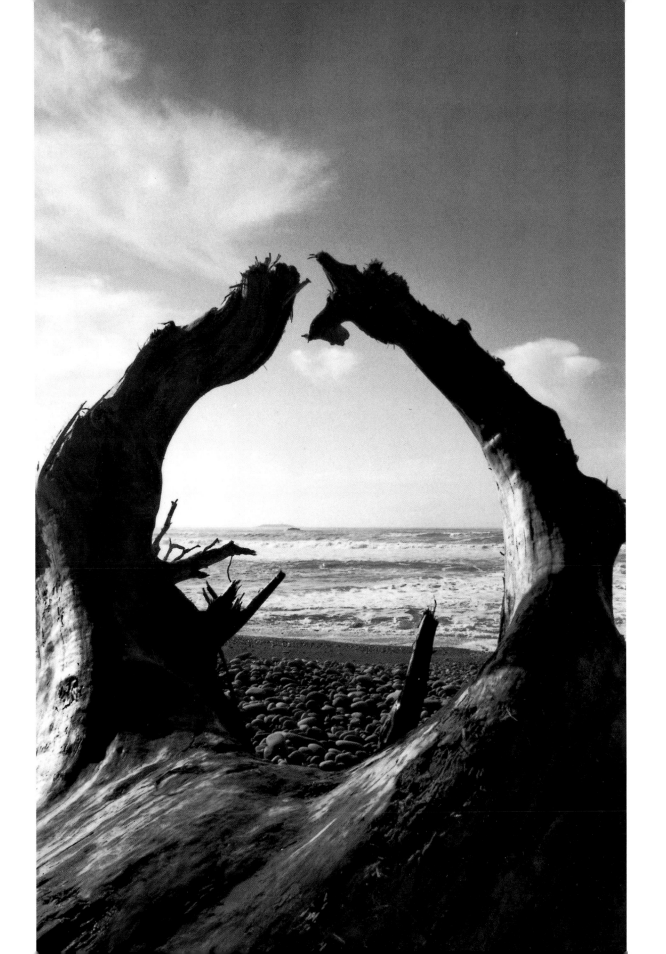

Light shines through the weave of existence,
casting veils to be set free,
designs of duality.
Take them back to their source.
Go home to other worlds,
where love is the doorway,
ecstasy the key,
and wisdom the light.

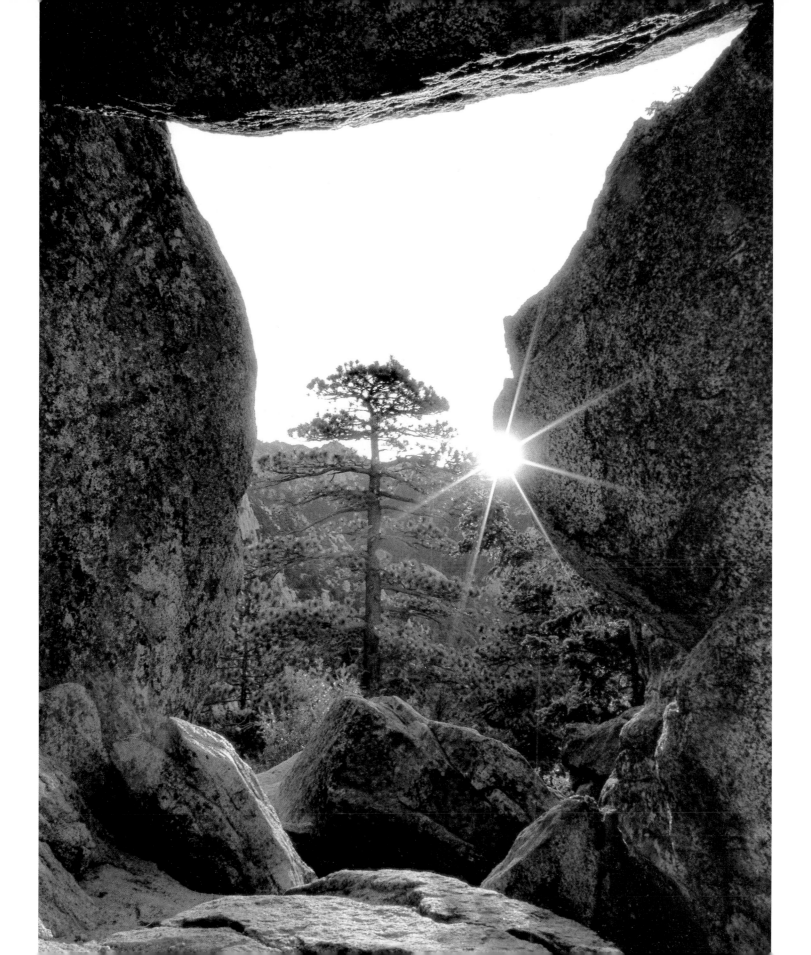

Libraries of Light

The ancestral trail began in virgin snow,
along rivulets of mica,
past ice-etched monoliths,
recording the morning light.
No cipher existed for the formidable
guardians that covered the Earth.
No one understood the holy rounds of galaxies,
solar flares or lunar landscapes.
The Mother was primordial, absolute.
Glacial towers chimed for her alone.
Time had yet to begin.

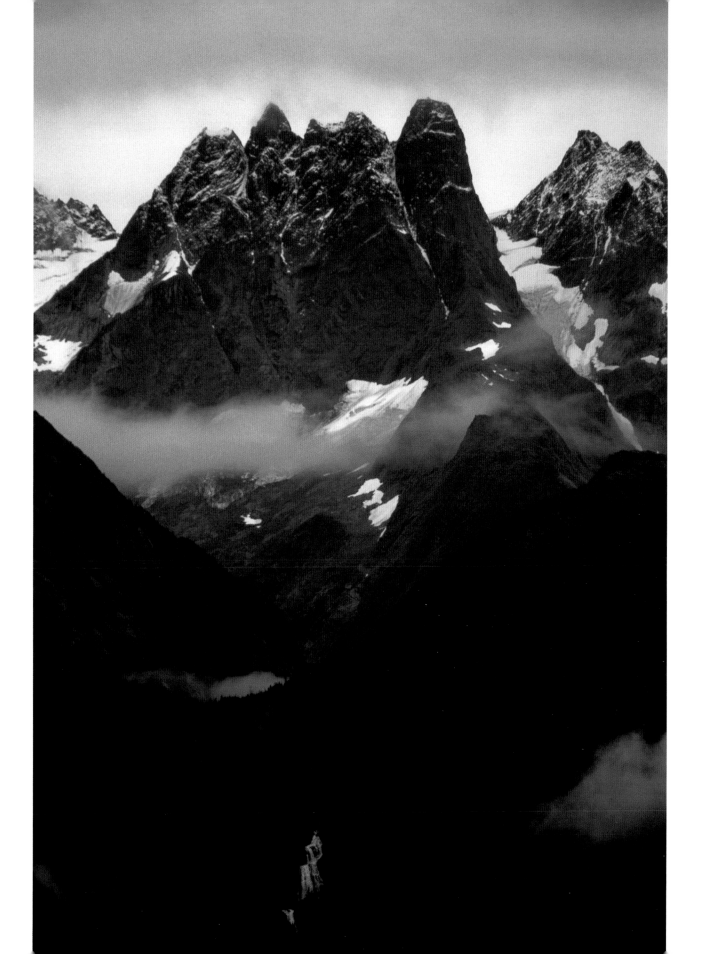

Creation

In the beginning, the Mother dreamed alone,
vast, unbodied,
spirit and endless possibility.
In her dreams she conceived the dawning.
Her womb was the cosmic sea,
her thought a divine child, a luminary.
And she sang, ever near.
Tidal rhythms made the child feel at ease.
The Mother's presence filled the emptiness.

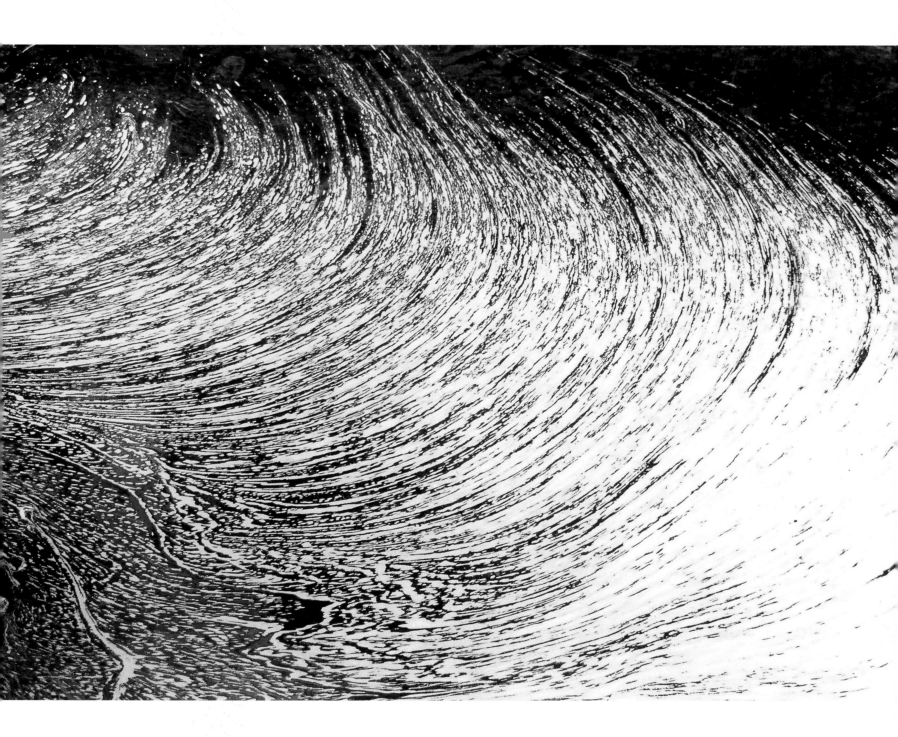

But the moment arrived,

and starry-eyed space shook the firmament.

The sea heaved in an uproar,

bursting over its shores,

and her sun-child was born,

clothed in hallowed fire,

bearing her warmth and love.

The world became plentiful

with mountains, rivers, and trees,

by the power of thought,

by the Mother and her Child.

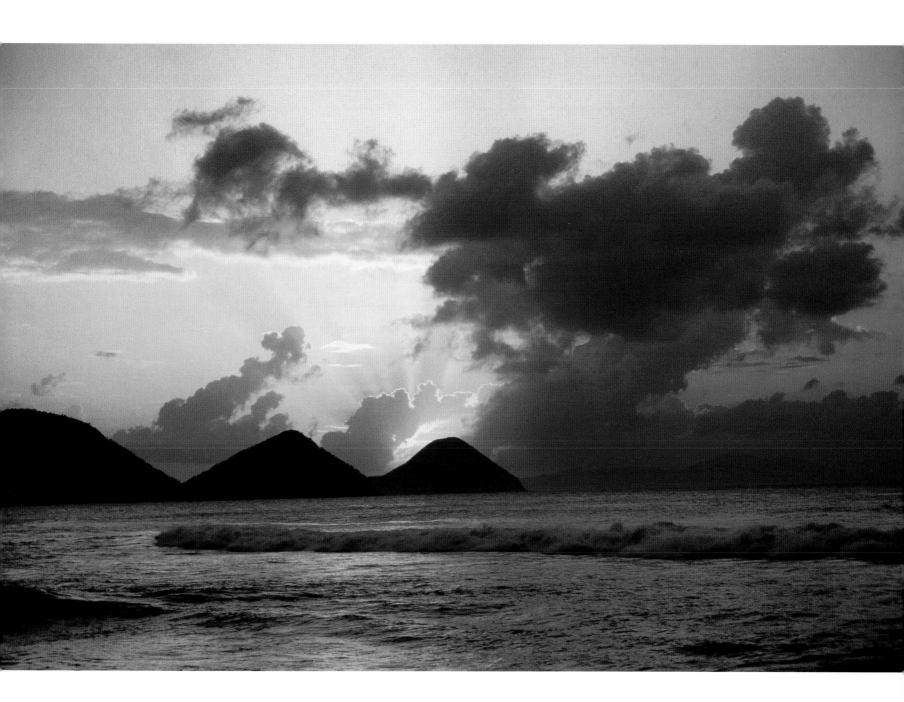

Out of the Depths

What draws us from our origins,
trembling into the daylight,
no longer solitary and nocturnal,
summoned to taste mountain lupine,
to heed the call of wild ones?

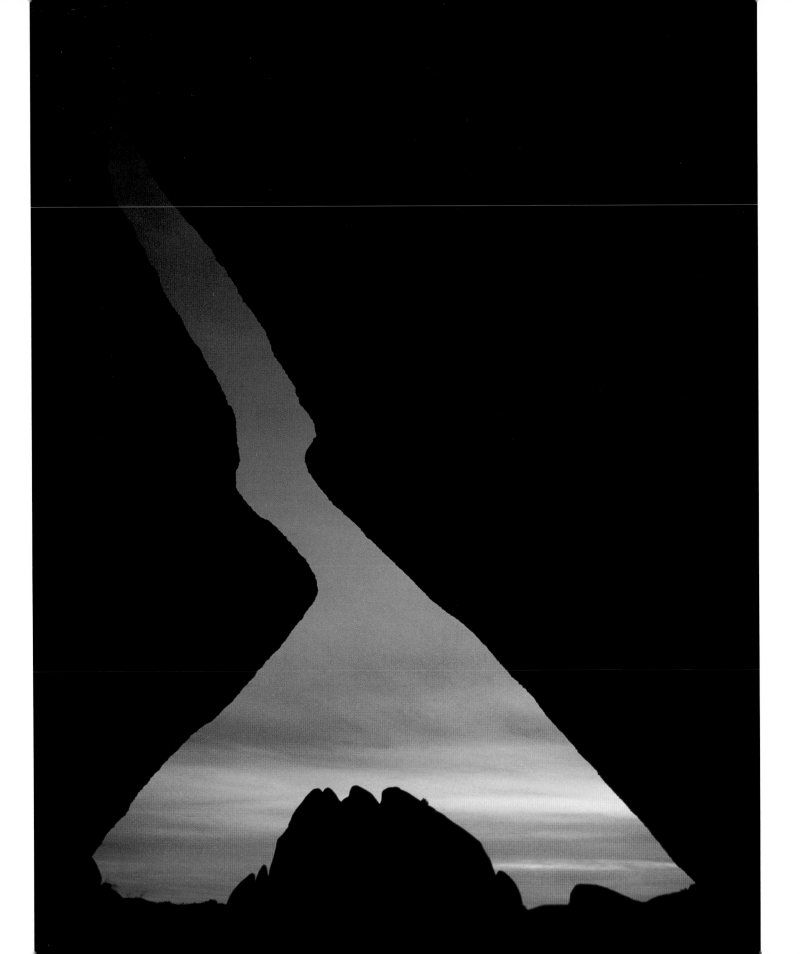

Is it the dripping, purple nectar,
the eve of the Earth,
the adam's apple sky,
the sun and moon rising
and falling within us?

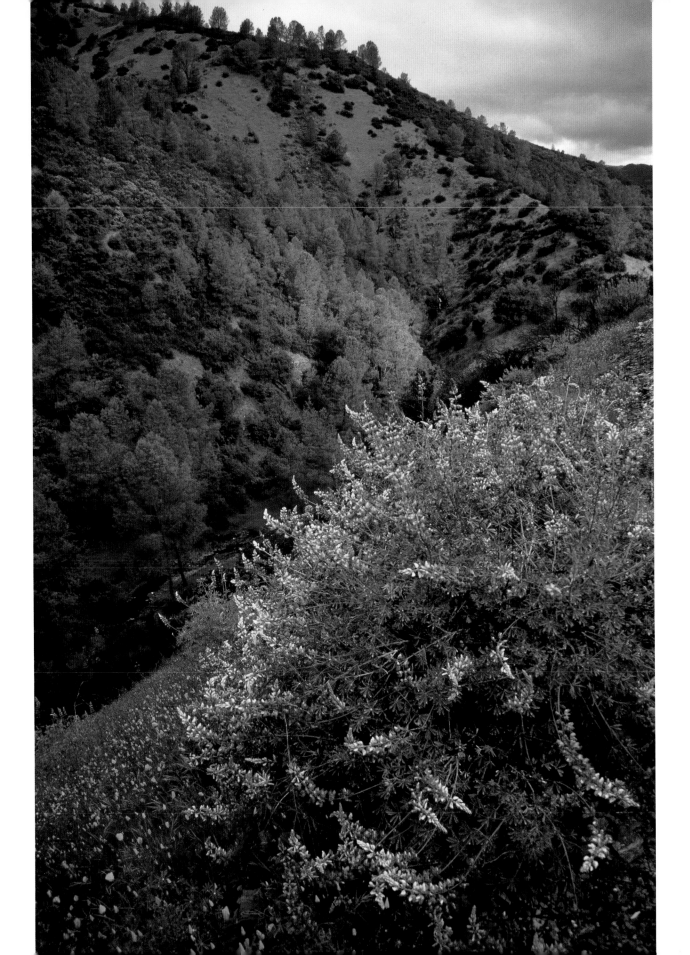

Is it the four-leggeds,

the two-leggeds,

the winged ones,

those whose rivers course into ours?

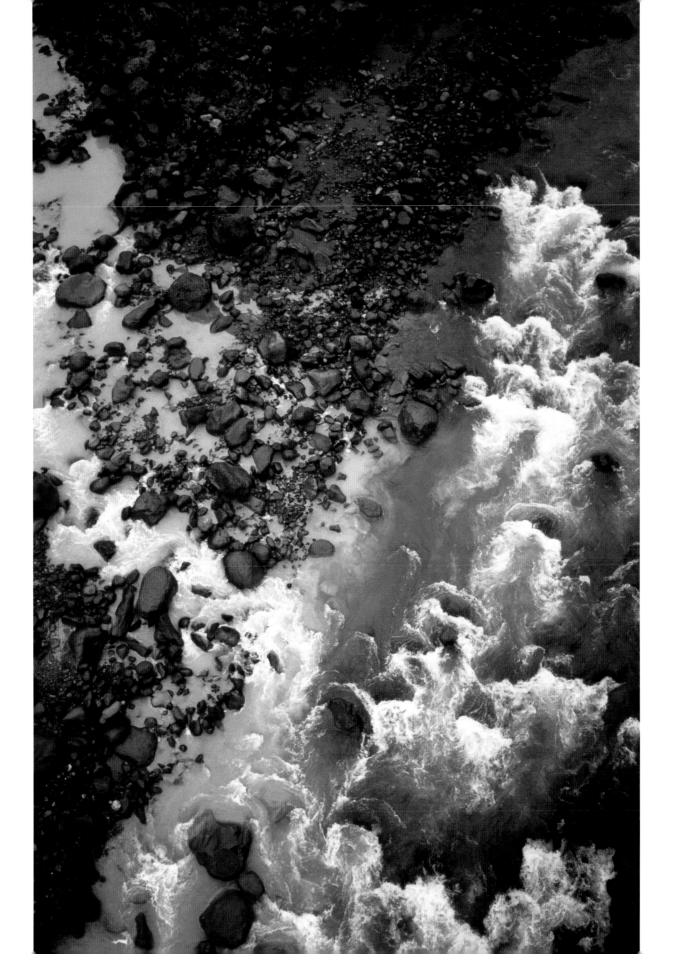

And what draws us back,
nodding on death's shoulder,
eyes wide in wonder,
taking bare, vulnerable memories,
the parables and poetry,
the heart's candle and drum,
tucked indelibly within the vision
of our new beginning?

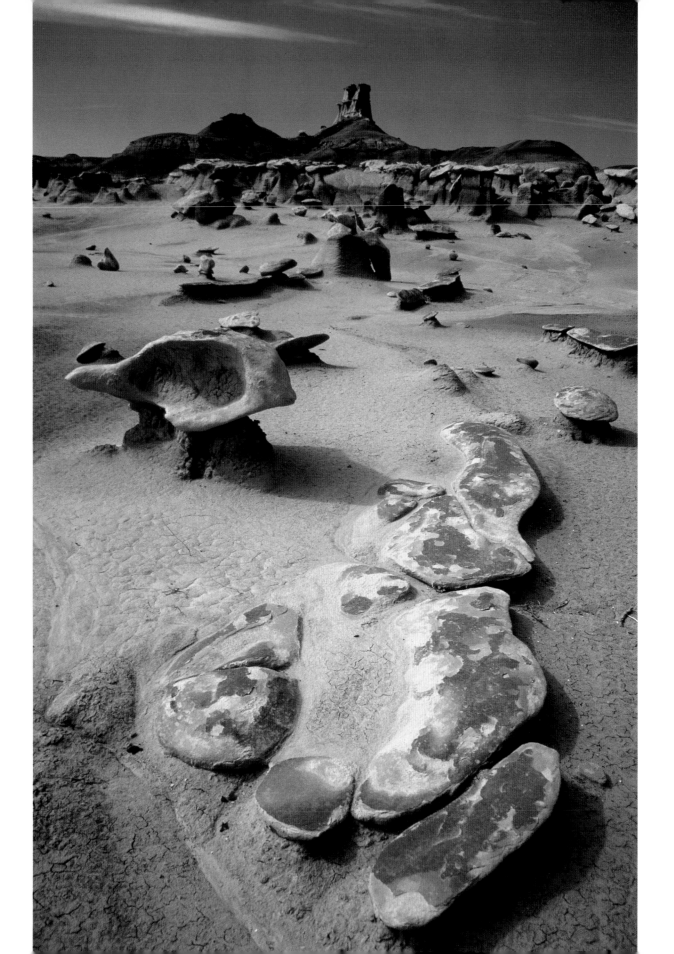

The Tao of Hoodoos

When intuition lights our way,
the still mind understands.
When things fall into place,
no maps are needed.
When we become the day,
the world arrives to meet us.
Life is not always what it seems.

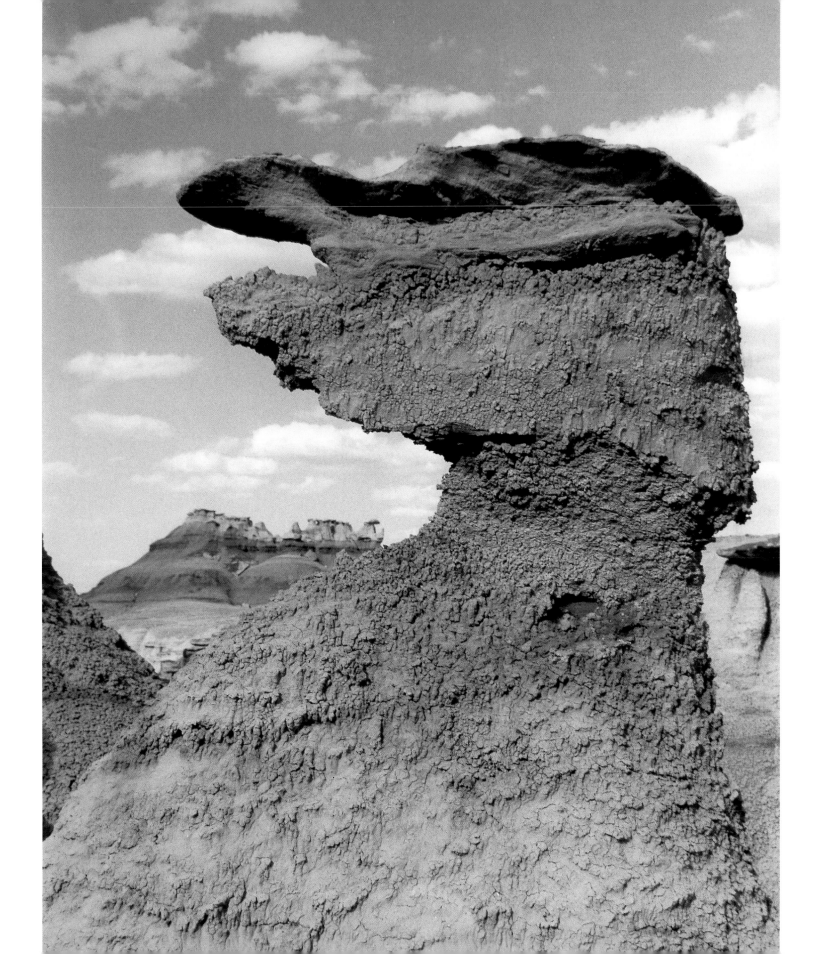

Vigil

I cannot sleep
while my jaguar spirit roams the night,
offering itself at the temple door,
waiting, poised for a sign,
a leap into the unknown,
a numinous presence peering through the mist.
I cannot sleep
until the synchronous beat of my soul's flight
transports me into bliss.
The jaguar drapes on a tree,
its heart drumming with the Earth,
while I ride the wind.

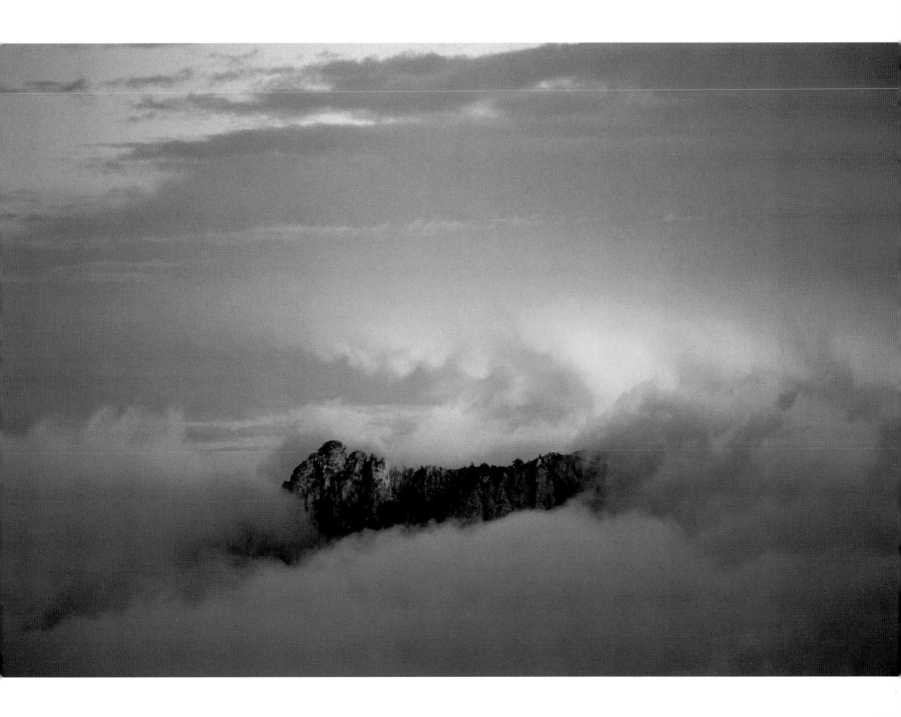

Moon Dancer

Twirling around an empty road,

dancing along an ocean of another mind,

moon-master of the moment

lures music from the stars

and enchants life.

And I, leaping into the moonlight,

flow, as life flows, into the unborn,

since time beyond time,

spellbound.

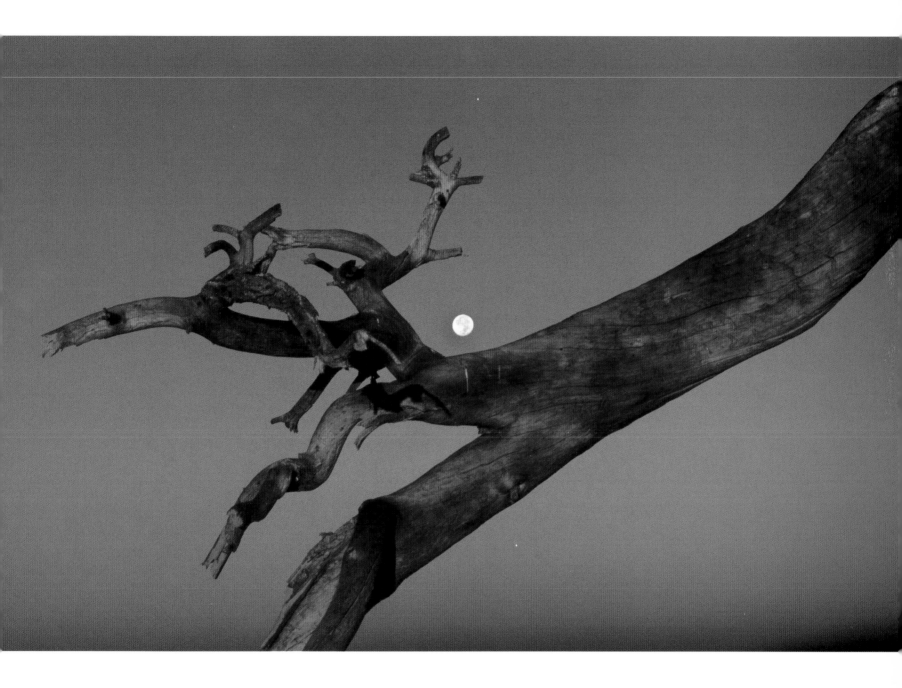

Learning to Fly

My soul cried out, plaintive and echoing,
to an eagle gliding toward the sun.
And in reply, a prevailing wind
rose over the towering peak
and entered my heart,
leaving me shaken as a downy feather
on the breast of creation.
Now all I know is that
feathers have grown from my own breast,
and vast wings span the horizon.
I am learning to fly on the mountaintop
where wind and wisdom are one.

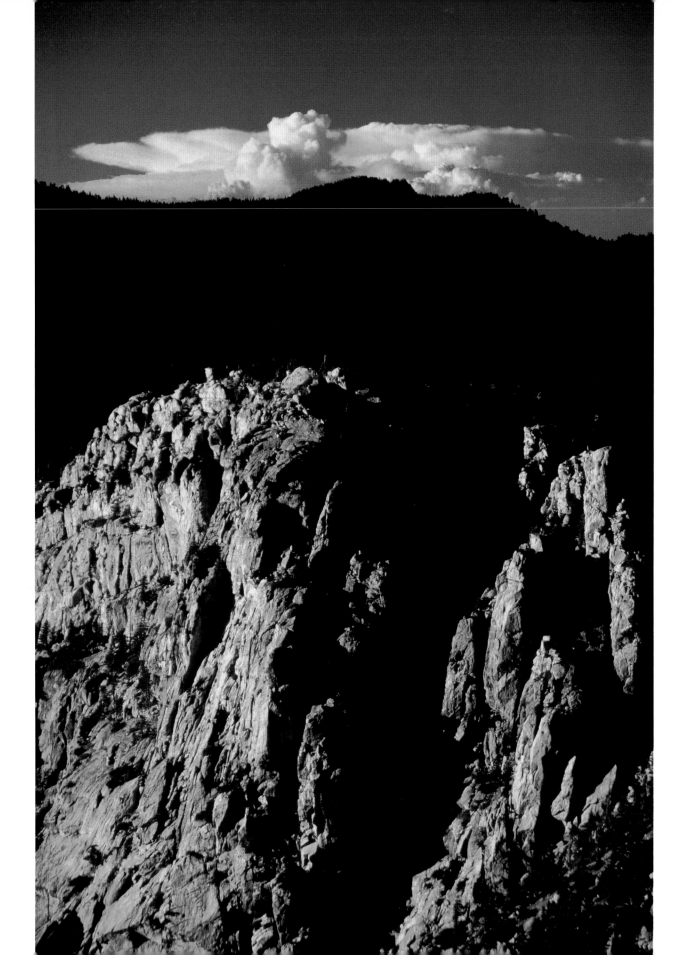

The Polished Mirror

This journey upon a rolling sphere
evolves the memory of our bones,
until we can walk upright again,
hearts open to the sky,
the sun mirrored upon the
summits of our perfection.

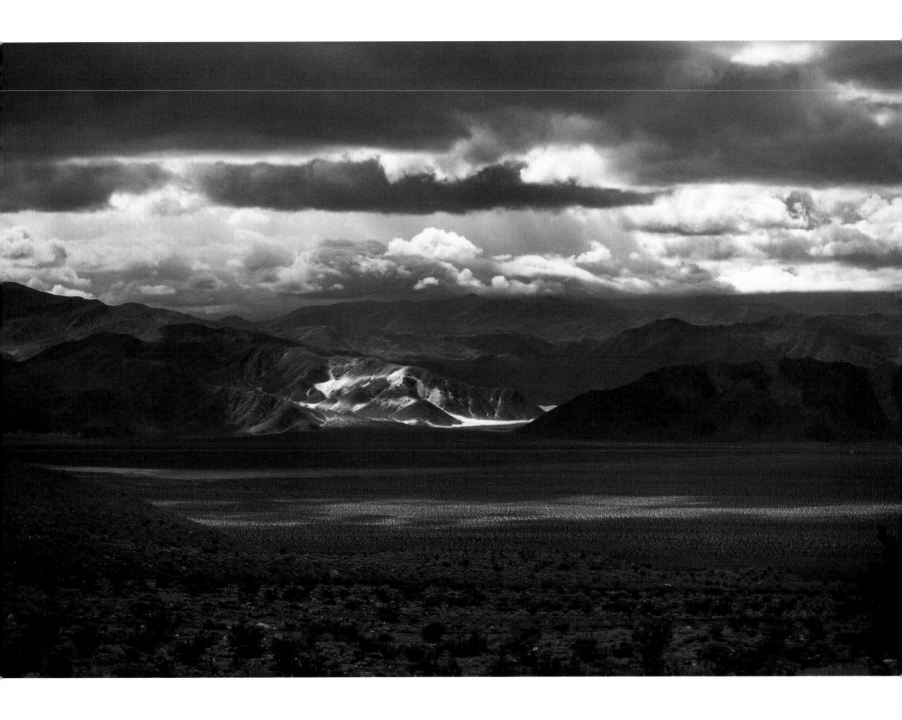

Speed of Light

If we wear light as vivid skin,
limitations vanish in a moment.
We realize we are more than we seem,
when the boundless vast stirs within us,
and our eyes shine eternal stars.

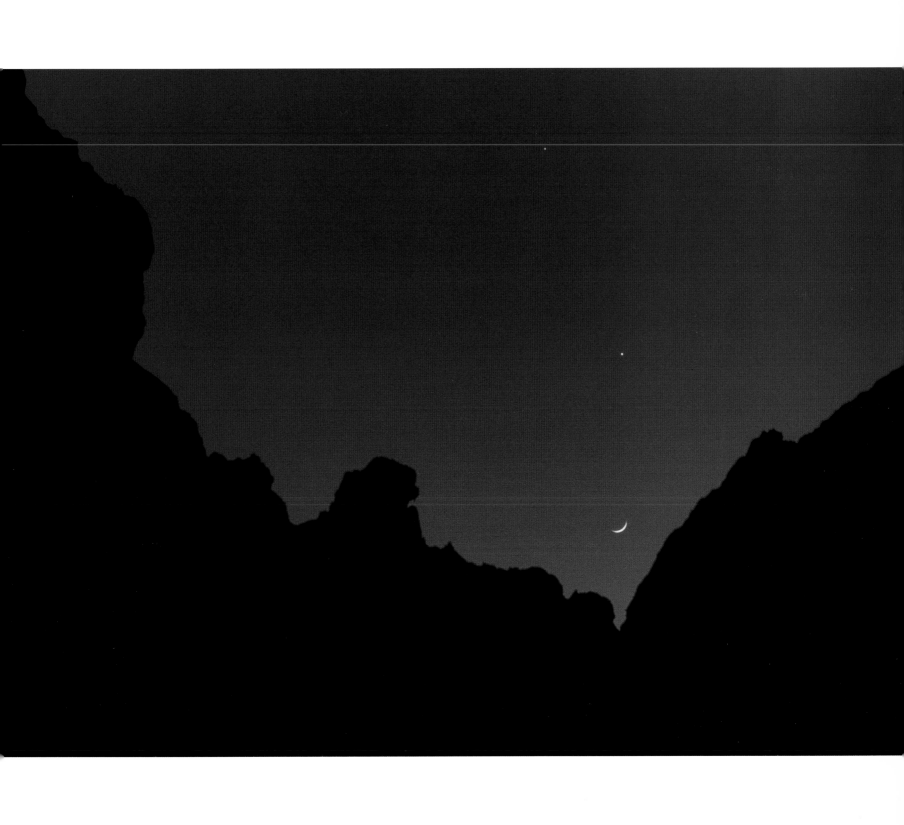

Aphrodite

I am a goddess within,
walking a sacred path of jeweled design,
healing my soul
with the beat of my heart,
with the beat of a drum,
dreaming with diamond eyes
the wisdom of ancients—
power in every glance,
beauty in every dance,
infinite mystery.

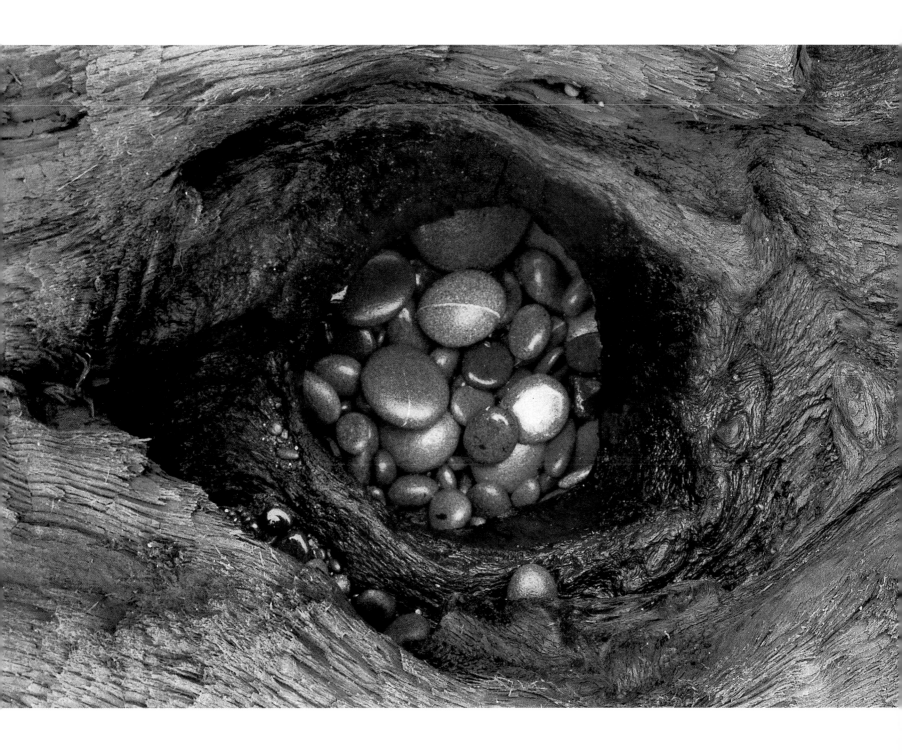

The One

She is the Mother,
the womb,
the heart pulsing in stone.
She is the longing to return,
the joy of being born,
and as waters recede,
she is the one found.

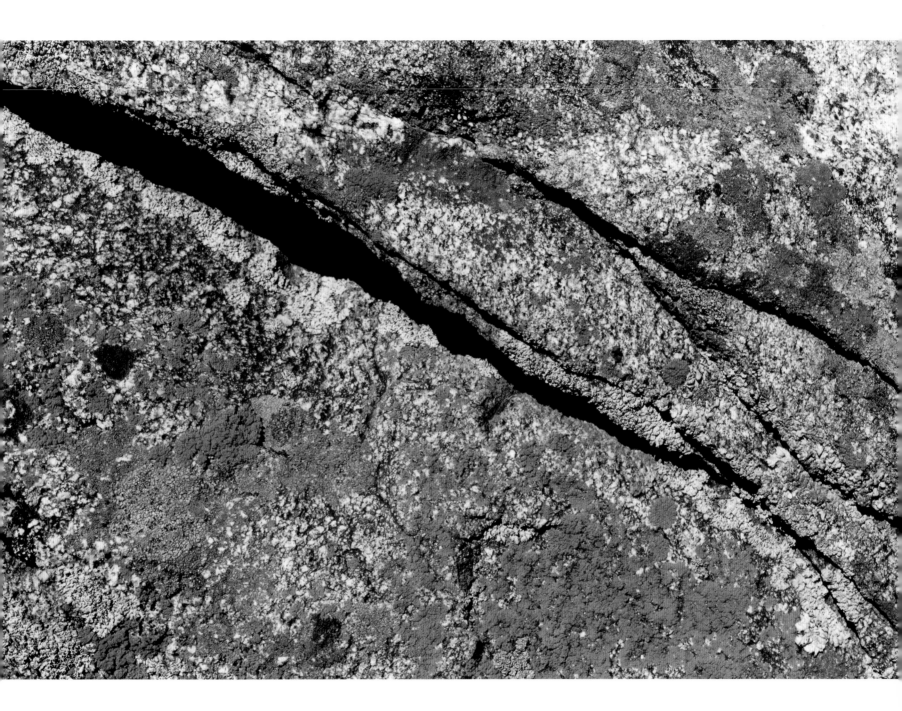

Innocence Twice Removed

Sacrificed to highway gods,
the luminous doe watched death arrive
on a cold, indifferent road,
pierced with burning lights, gasoline, and dread.
Her chestnut neck arched one last time to the sky,
searching for the thickets and springs she loved.
Anguish, ancient and unwanted,
rose from my soul.
I knew this deer,
driven numb
in a world of little meaning.

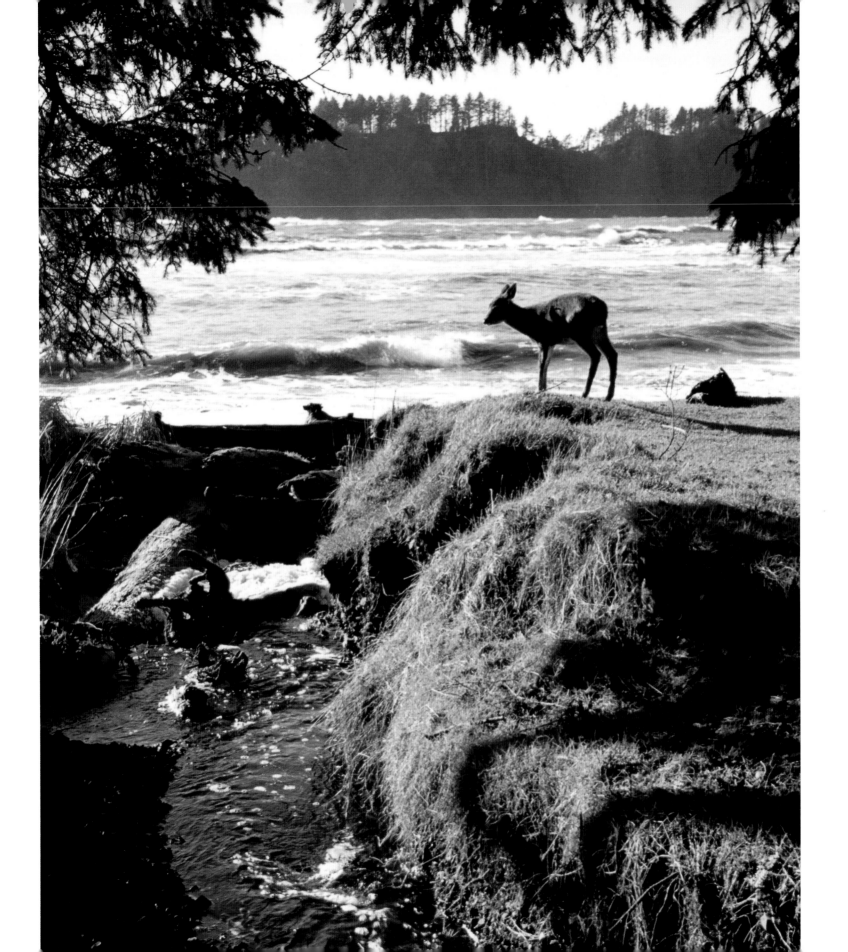

The Quest

The passionate movement of a seeking heart
calls for a vision that penetrates the soul
and for words that live within us,
invokes lightning and thunder at twilight,
and rescues the child in the wilderness.

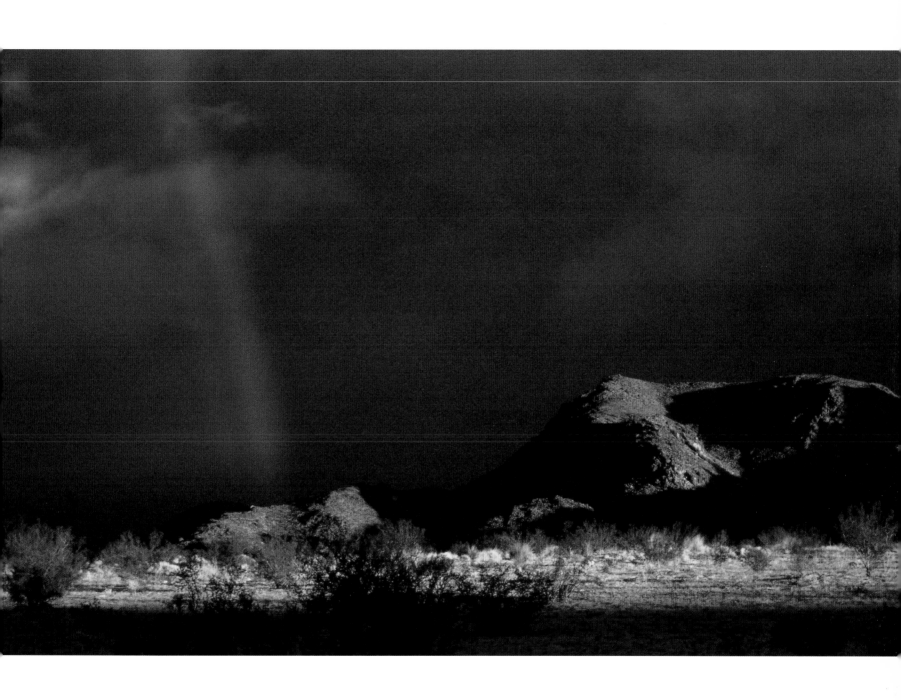

Alliance

Mystery waits in silent pools,
liquid and smooth,
form without form,
hidden beneath the surface.
We float in these waters
of no beginning and no end,
united on a bed of reflection.

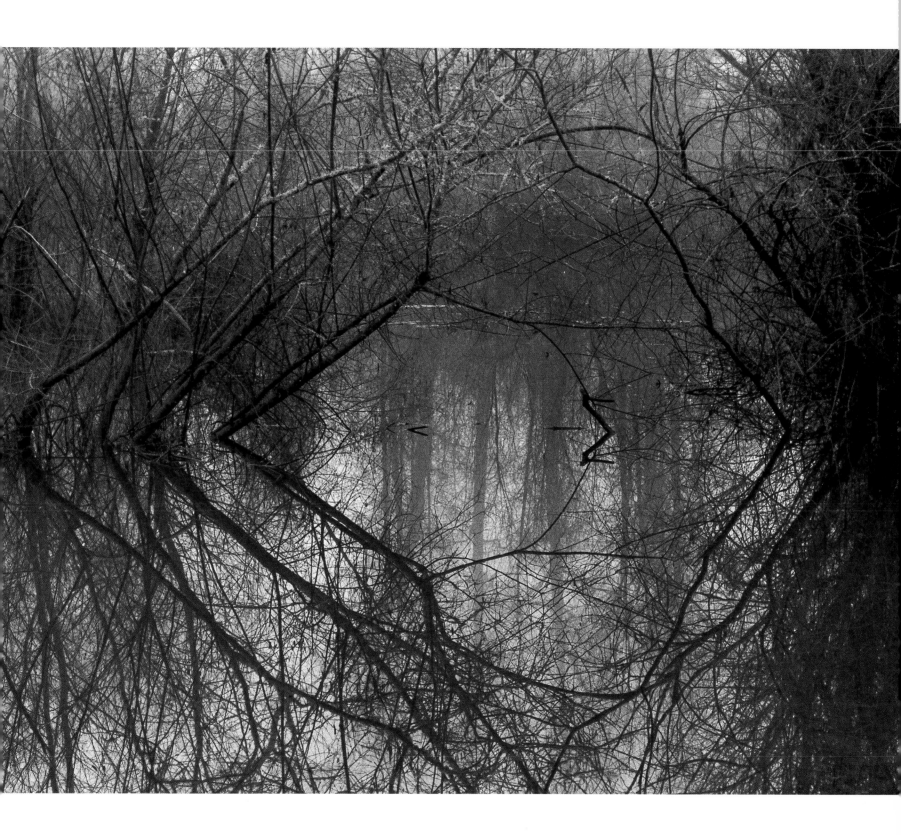

The Odyssey

We live in exile,
bound in gravity's tight grasp,
tethered to the day
and to the stormy night,
dense as a fallen star.

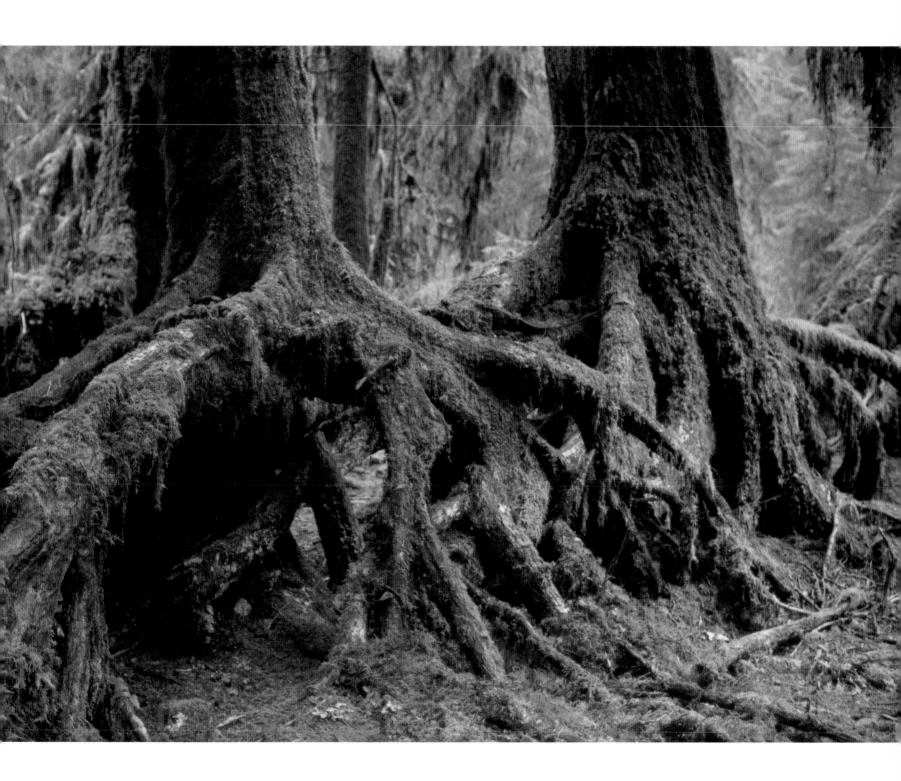

But the Creator rises from within,
weightless and universal,
as light becomes our chosen path
on the final migration home.

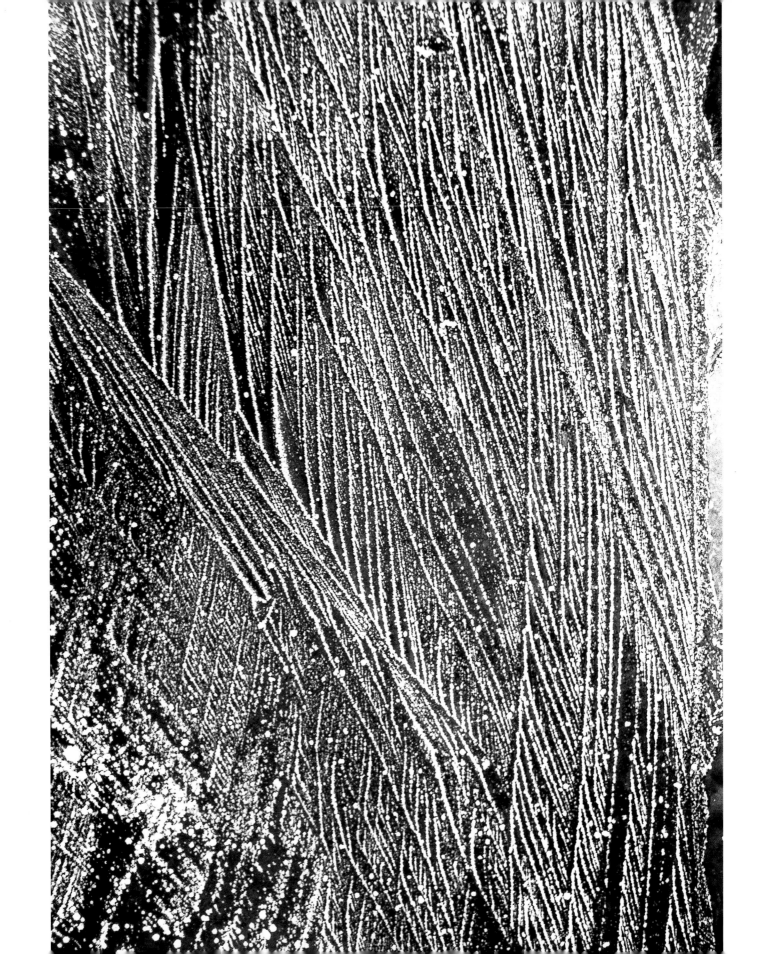

Passion Play

You are the bestower of life,
never-sleeping,
birthing the future with each dawn.
You are the soul of the world,
giving itself to itself,
gliding fresh, unsullied to the sea.
Rooted in bliss,
swimming in heat and dew,
you are the sweet taste of paradise
inherent within all things.

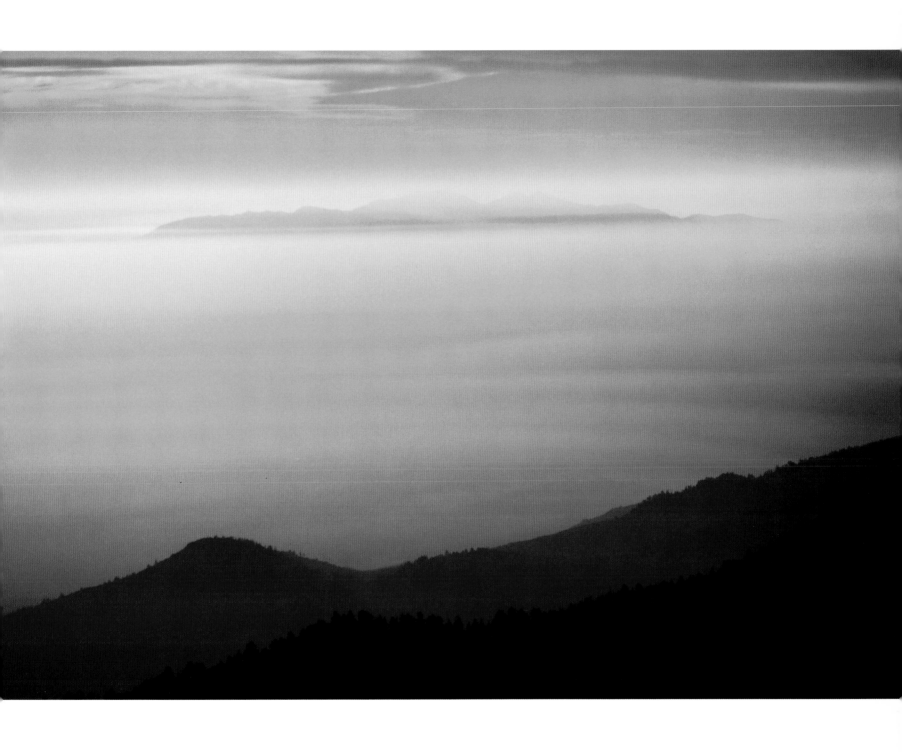

Reverence

The air brims with revelation,
rich with seed and ripened fruit
from the core of creation.
She has risen—
Queen of Heavens,
the spirit of nature, before my eyes.
The path is scattered with truth,
maps inscribed at my feet.
I can only believe
love is the root of all things.

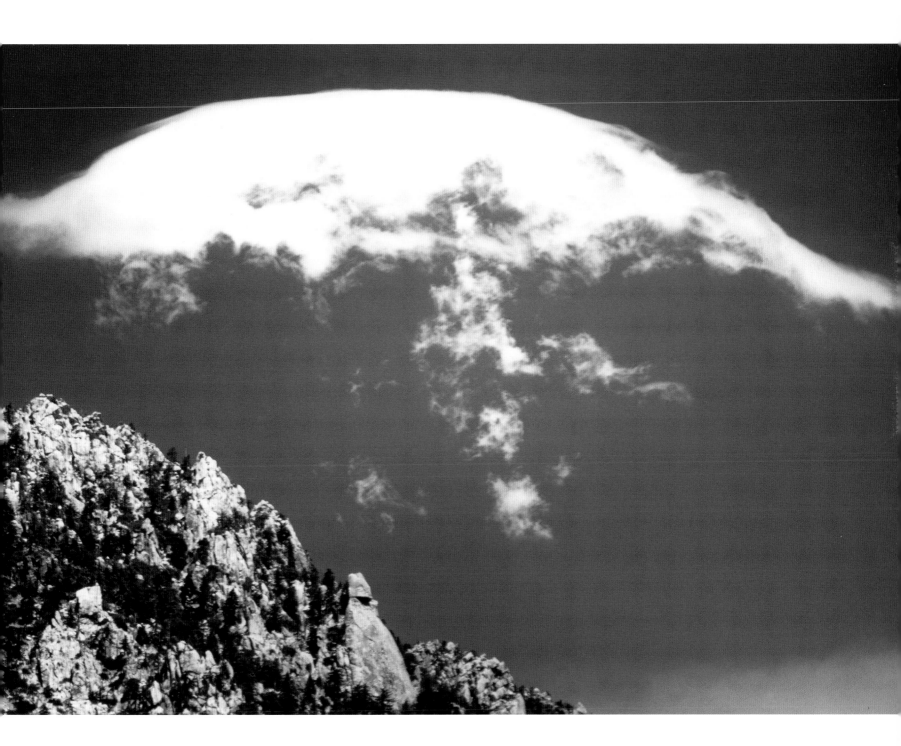

Gatekeepers

When I speak to the wilderness
with my heart more than my mind,
the world responds in kind.
Immortals whisper my name
from the forested ridge,
their breath in rhythm with mine.
Love fills my life,
as I immerse myself
within the patterns of Nature
and flow, unfettered,
sublime.

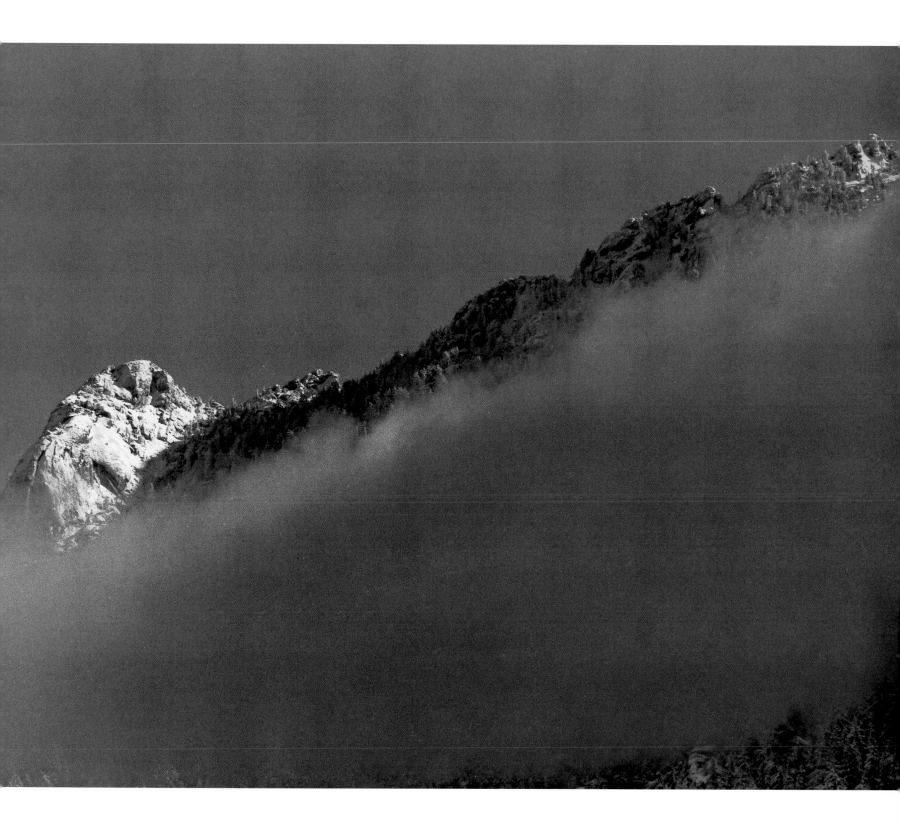

Bed of Flowers

Indian paintbrush grow on the cliffside
with rose and coral blooms
suspended over the valley,
holding the dew of the day.
Storms at sea have sent the wind
in search of something holy.

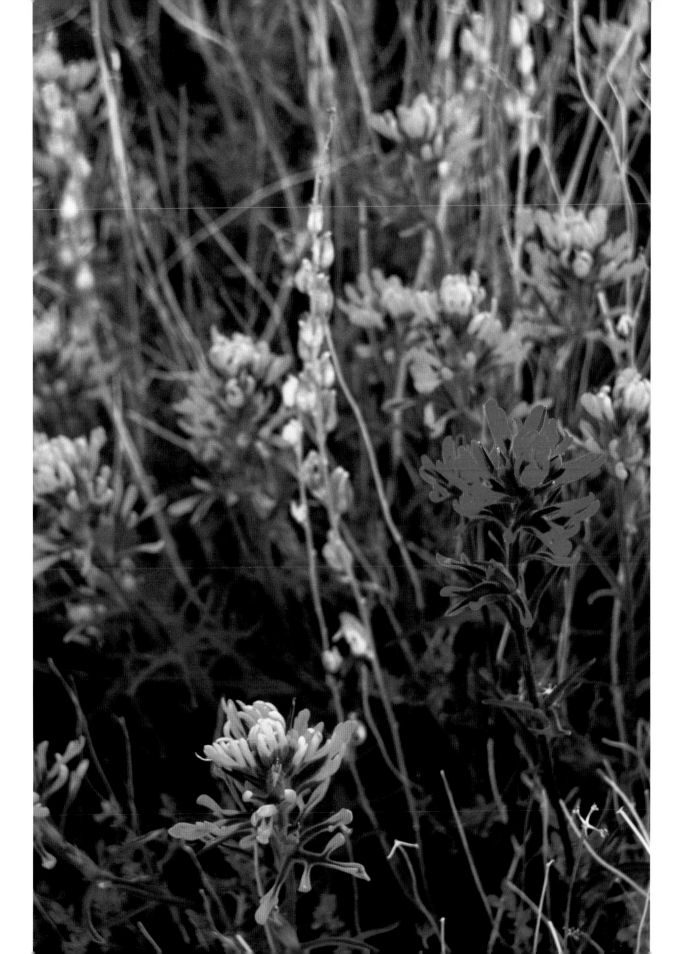

Blessing Way

An angel sings through my heart
like a silver-toned bird.
Now I have feathers to spare and
wings to reach a most sacred place,
the well of wisdom I once knew.
Angel by the well waits with the message.
Time does not exist.
We are in concert forever,
heart to heart.

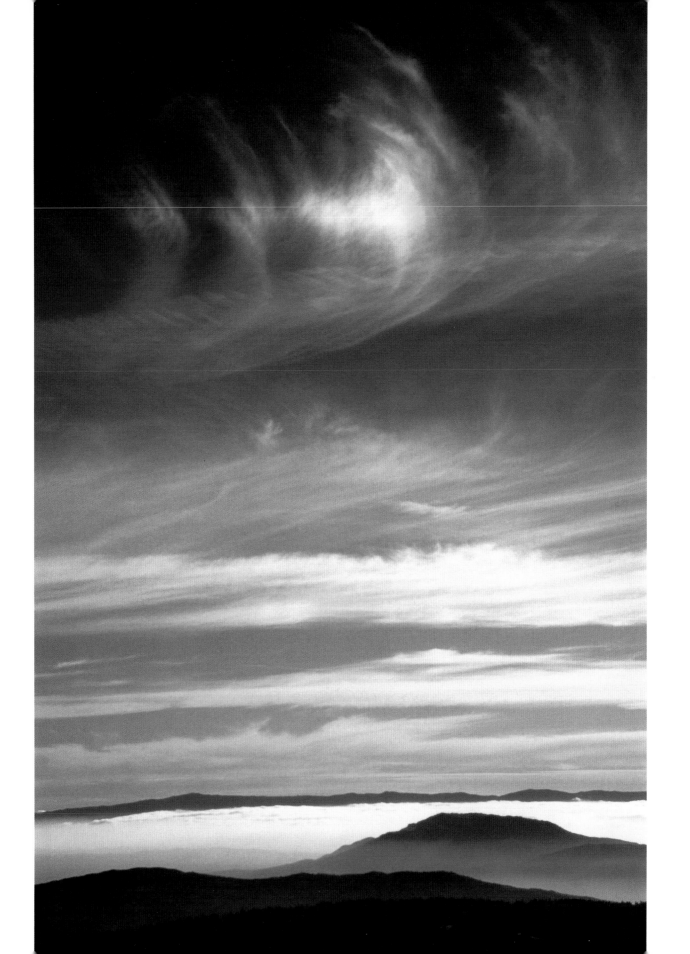

Ode to Artemis

O beautiful Artemis—
lady of light,
maiden, mother, crone,
goddess of wild nature,
guardian of the young—
guide us in times of darkness,
flow through us like moon on water.

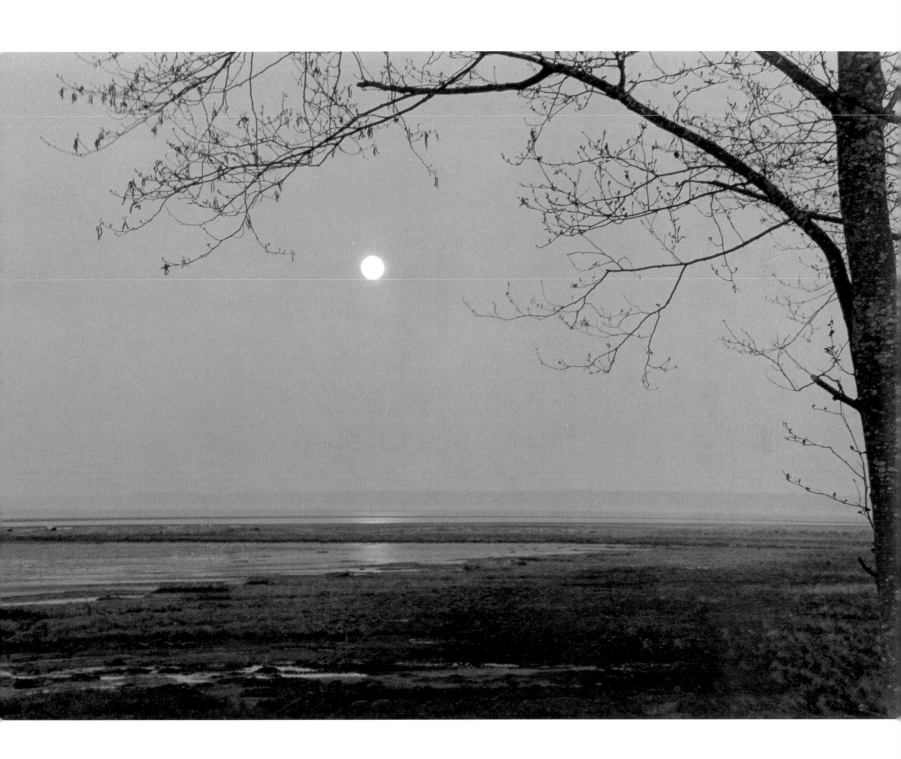

Redress

Autumn, release what we no longer need.
Cast the past onto banefyres of deadwood.
The masquerade is over.

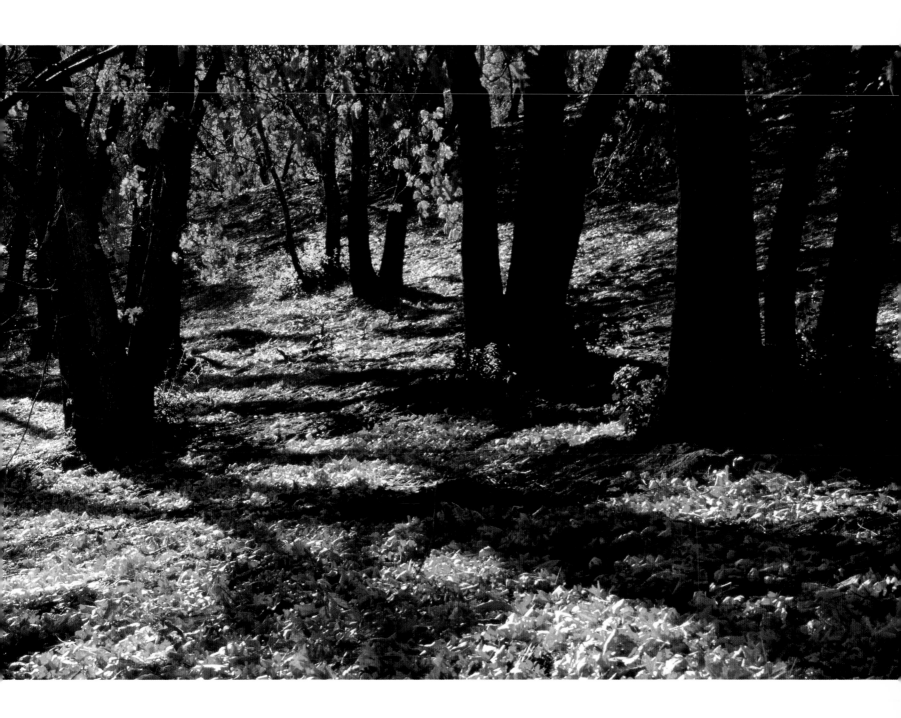

Garbed in light,
fearless, redeemed,
we walk without judgment,
as silent clouds haunt the skies,
motioning the way to freedom.

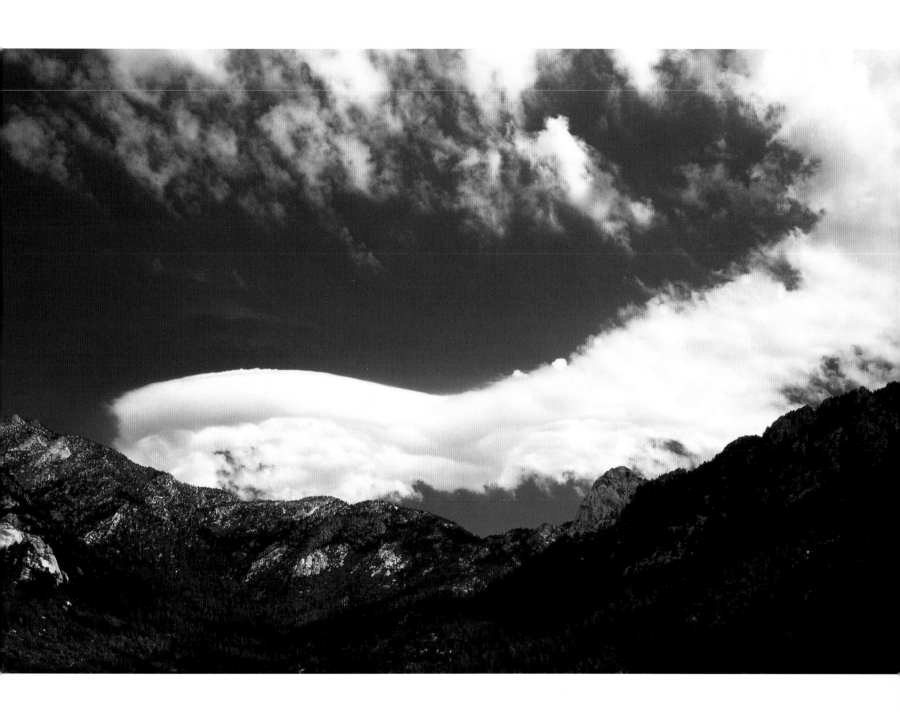

Power of Silence

In the power of silence,

know the moment of creation

and birth fields of fresh-fallen snow.

In Nature's perfection,

softly wander about

the landscape of souls,

feeling in the wind

the touch of all that has ever been.

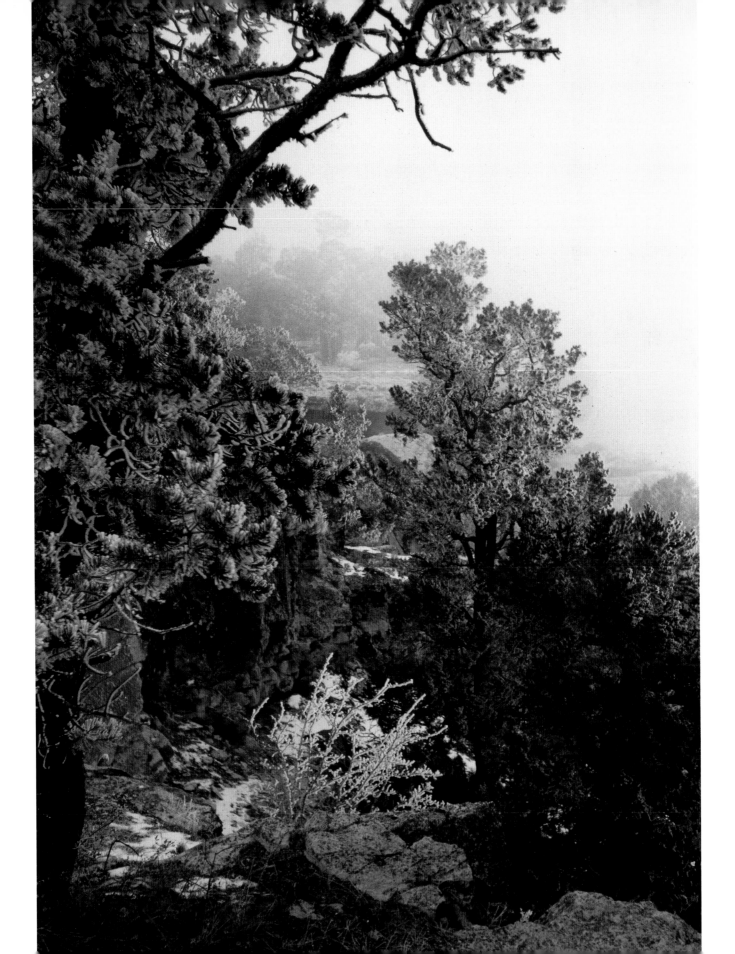

Celebration

The ocean speaks
to all levels of your being,
of your power and beauty,
of infinity and healing.
Yes, you are all this.
Yes, you are one,
your soul and the sea.

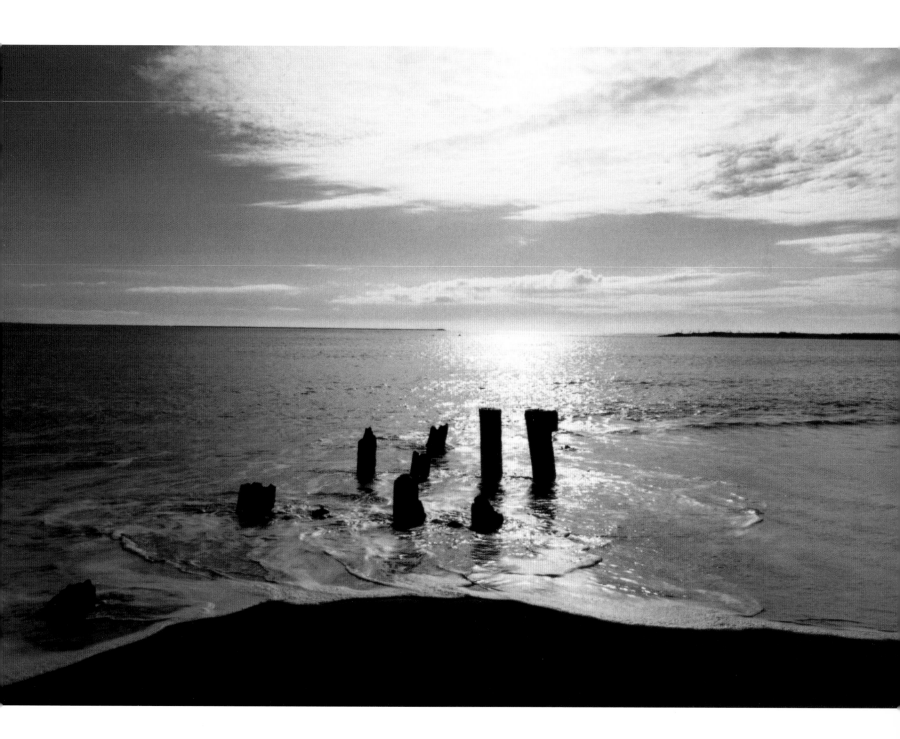

Transformation

Does a snowflake,

flung from an angel's wing,

trust the fall,

not yet knowing the grand design

or what it will become?

There is a patience,

a whisper of natural order,

as it follows its innate path,

anchoring light to Earth.

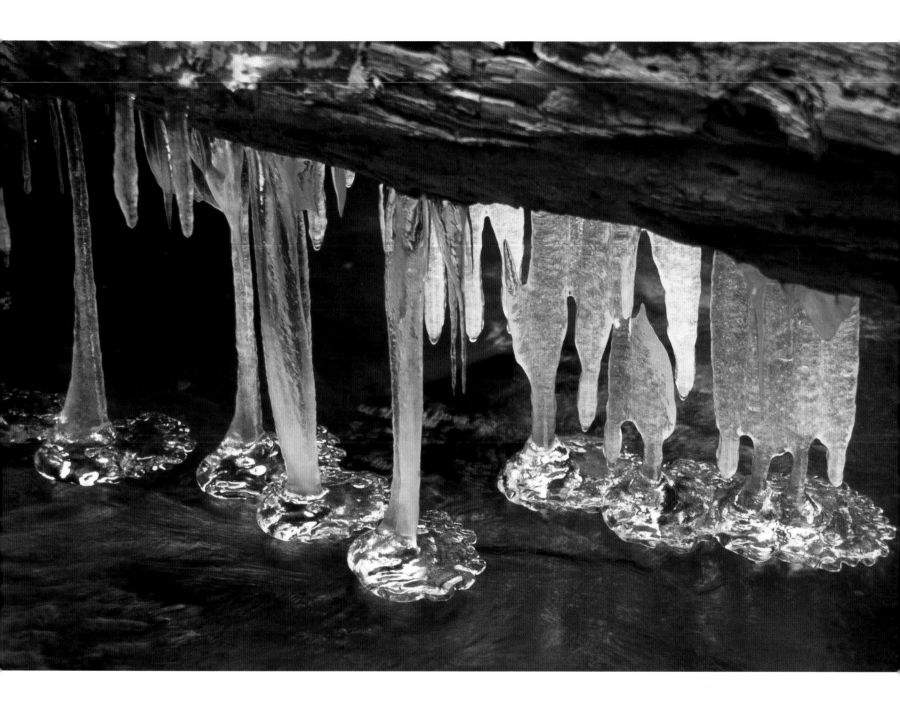

Sanctuary

Great Mother,
we ask for your blessing.
We open each chakra
to your permeating essence.
Let it fill us with sweet nectar,
our plumes quivering
as we bathe in your light.

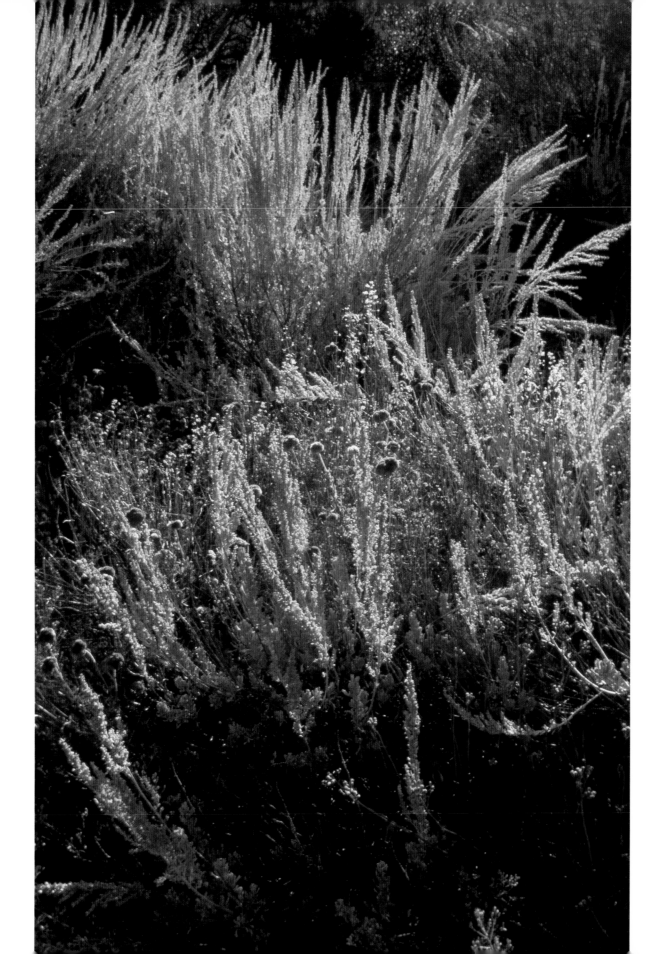

Luna

Transfuse my heart
with the blood of silent trees.
Make my bones branches,
your words a gentle wind
rustling through my leaves.
Transform me
until I am a mountain,
a muse in flight,
etched in eternity,
buttoned silver in the night.

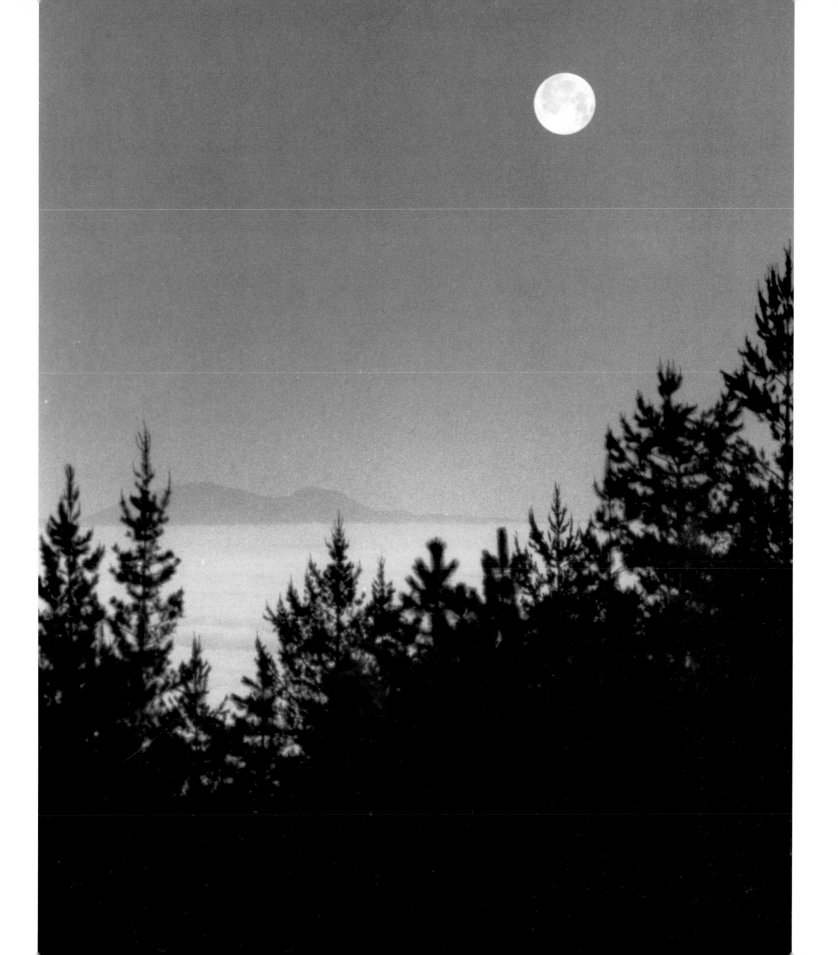

Unannounced Angel

There is nothing left of me.
Grief, hidden in the darkness,
shakes one last treasure from my breath.
In the surrender
of every dream and desire,
emptiness rings through the corridors
with only space waiting,
only being,
no consequence.

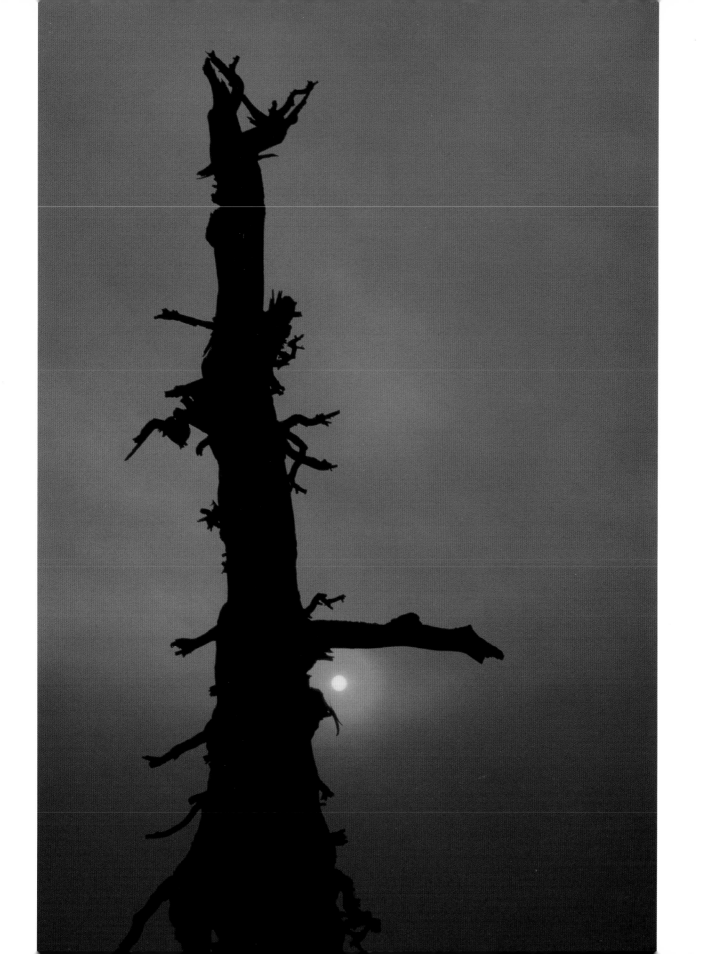

Slowly my heart unfolds,
showing its face like an unannounced angel,
unlimited, undaunted.
The words—hope, *esperanza*—wet my lips.
Beyond logic, I will survive
to dip my wings again in joy.

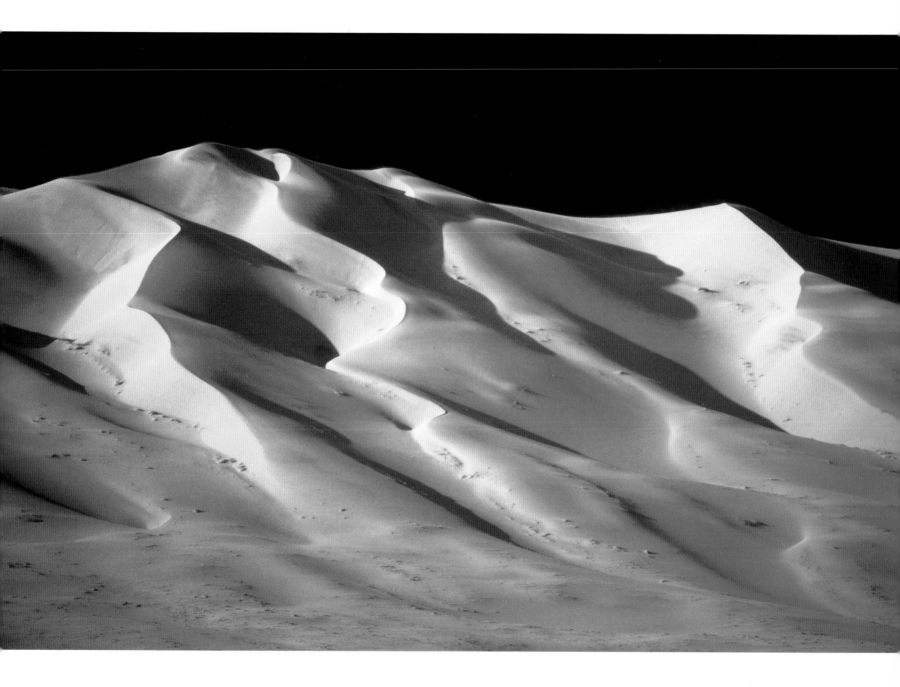

The Eternal Walks with a Smile

I am star woman,
tree woman, moonlight.
I am a riverbed,
and you are a painting done in oils and lava,
a sunrise streaked with lightning.
Throughout the far reach of time,
creation reigns.
The eternal walks with a smile,
knocks at your door, saying,
Let me in. I have a present for you.

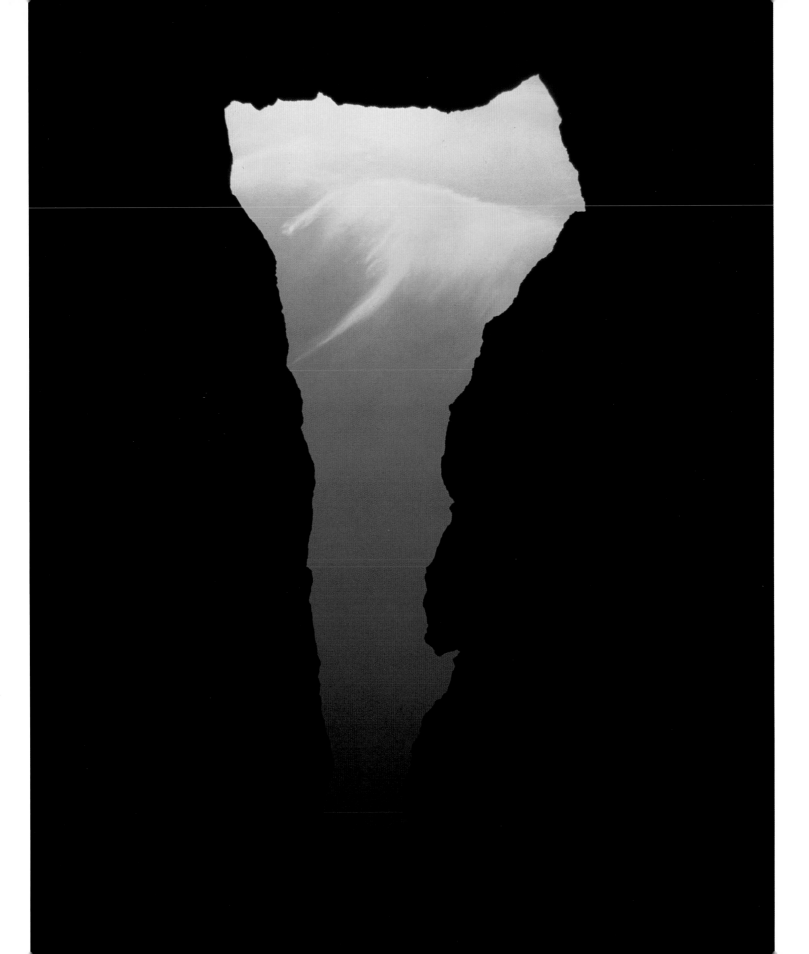

Let There Be Peace

The faerie hands of a pagan wind
gently disrobe me.
This body is not a sin
but a threshold to splendor—
Earth's song of praise
to the beauty and mystery
within us all.

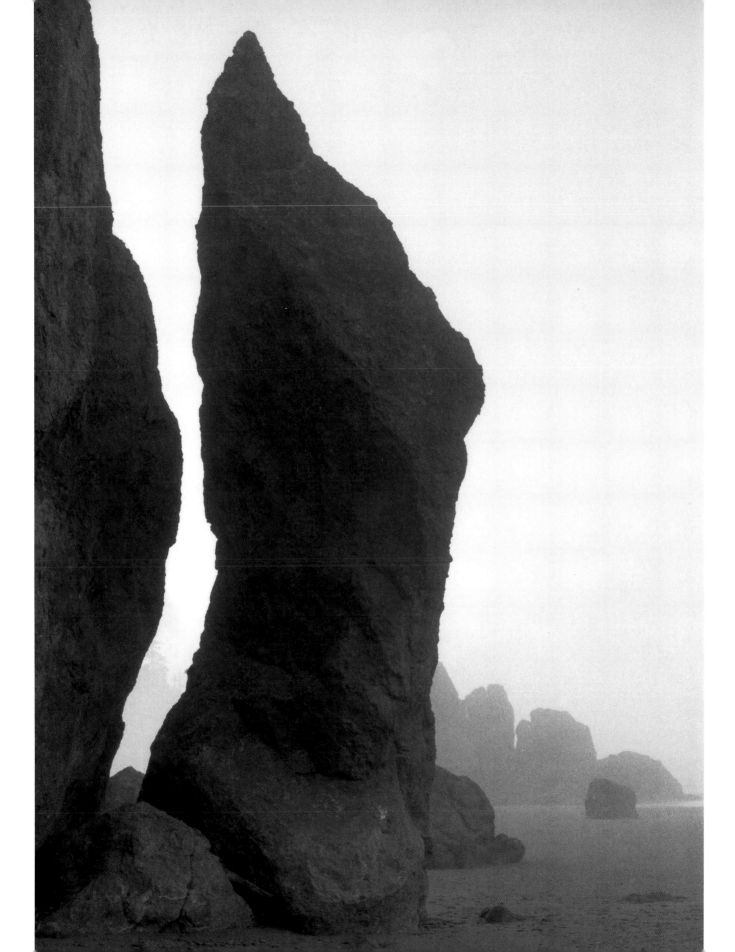

Call me a lover of sacred waters.
Long after I am gone,
you will find me there.

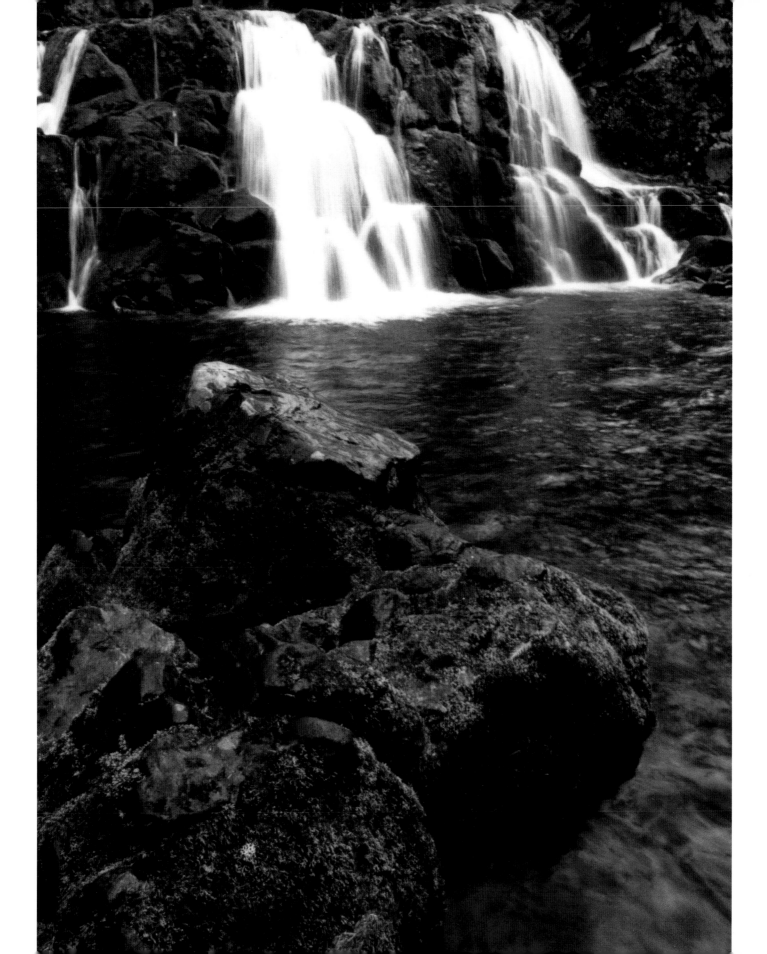

Passage

Immortal instinct runs underground

in spiraling pools,

holding mountains to its breast in the dark.

Streams of centuries spill

over tapestried cliffs,

while in the far distant world of man,

voices cry out

that we are only a body that will end.

But we have listened to the river—

dreaming of the sea—

and know otherwise.

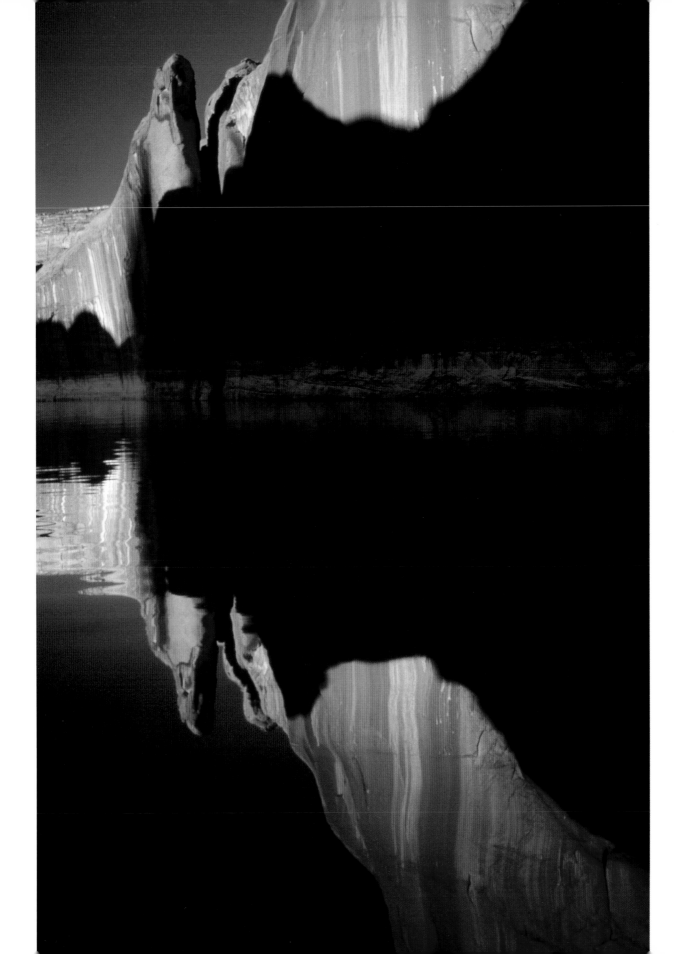

The Key

The ancient door opened.
The sacred land beckoned.
Walk with me.
See with your heart.
In the truth of eternity,
you will know you are not alone.

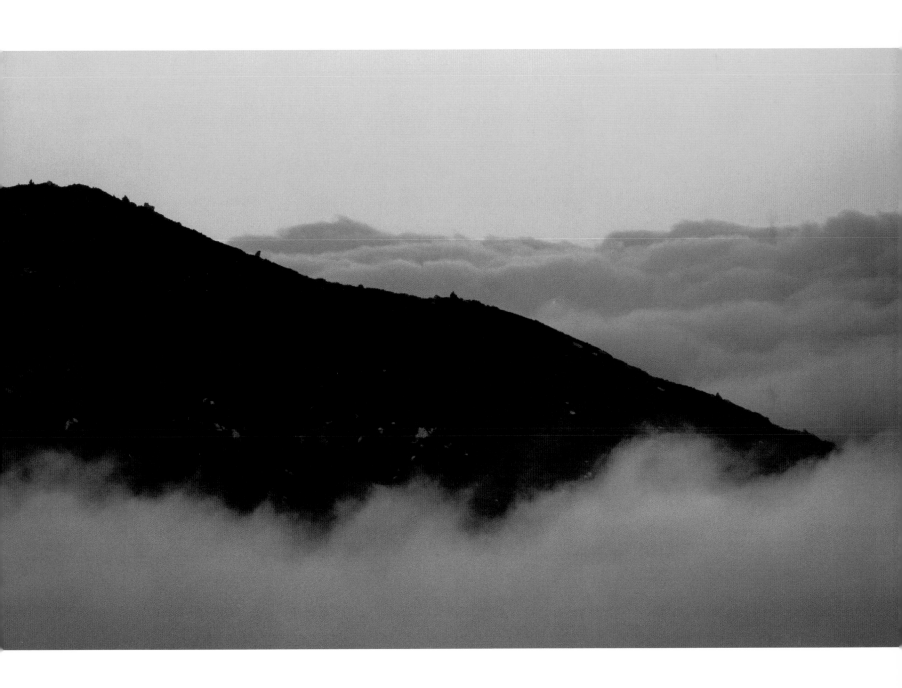

Intimacy

The Sacred has waited long enough.
Creation begins with union.
Let me in,
as I will you.

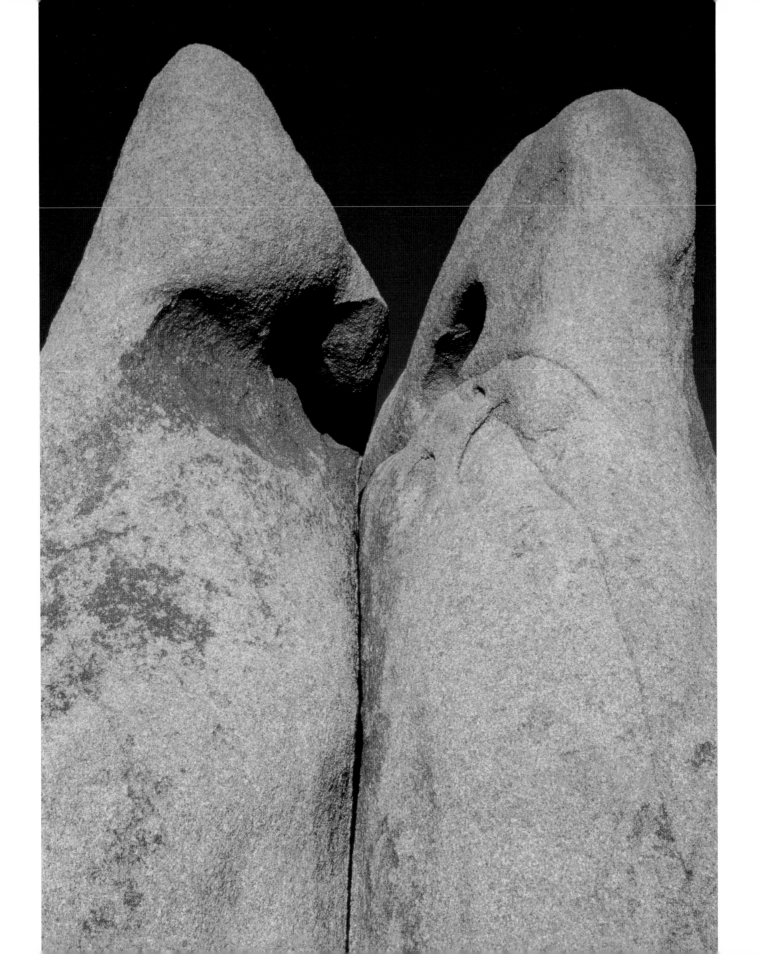

The Source

Life is a question
of connection or separation.
What we truly desire is already true,
for we are reflections in the Mother's eyes.
She has given us her word.

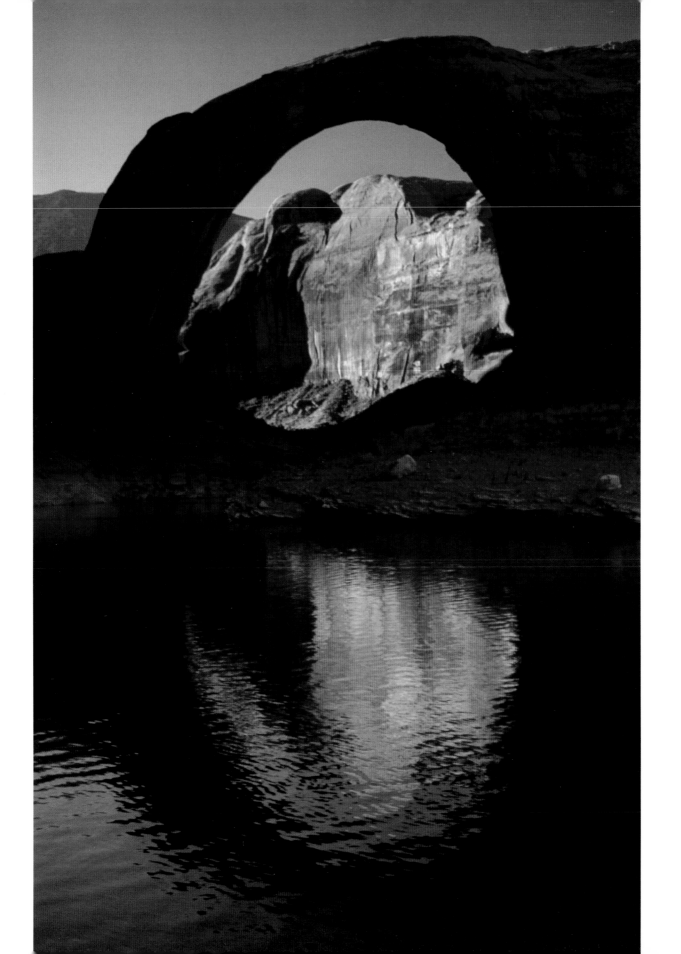

Photograph Locations

Poem Index